FOLK PORN, SEXUAL ANXIETY AND AMERICAN MASCULINITY: THE PHILADELPHIA FOREMAN

BY ALISON M. GINGERAS

In recent months, anxiety and porn have gone hand in hand—or at least, as Dr. Freud might have said, an unprecedented viral pandemic has brought the entwinement of sex and death to the fore. Since mid-March 2020, Pornhub made its premium service free for citizens across the globe, proclaiming, "With nearly one billion people in lockdown across the world because of the coronavirus pandemic, it's important that we lend a hand and provide them with an enjoyable way to pass the time." Likewise, as various municipalities have published guidelines to social distancing, the City of New York elicited raised eyebrows and embarrassed giggles with its incitation to autoeroticism during the crisis. The Department of Health's March 27 press release made tabloid headlines: "You are your safest sex partner. Masturbation will not spread COVID-19, especially if you wash your hands (and any sex toys) with soap and water for at least 20 seconds before and after sex." We have flattened the curve by collectively staying home and spanking the monkey.

In the early days of the pandemic, porn consumption skyrocketed. Pornhub regularly updates its website traffic statistics, and these have shown porn downloads spiking in parallel to infection rates and mortality numbers. For example, in early March, homebound Italians consumed 57 percent more porn than previously, suggesting that, for very many in confinement, the fear of death and disease inflamed rather than extinguished their sexual urges. But these prescriptions for solitary sex were not occasioned only by the need for social isolation. Public officials and Pornhub executives alike were actually enlisting the pleasure principle—our primal instinct to seek immediate gratification to reduce psychic tension—as a diversion to keep people off the streets and as a coping mechanism to calm our collective anxiety about this new mortal threat.

In what seems like collusion between public health policy and our subconscious, the compulsion to eroticize fear is even playing out in the emergence of "corona porn," a genre featuring quarantine-themed scenarios peopled by sex workers wearing medical uniforms, masks, hazmat suits, and an abundance of latex. Psychology Today noted these trends, specifically relating the sexual fetishization of the virus with how anxiety operates: "High-fear states have the potential to amplify sexual arousal and attraction.[1] If people are on edge from coronavirus news (meaning they're in a heightened state of generalized physiological arousal) and, say, see a media image of an attractive person wearing a mask, this could lay the foundation for them to start sexualizing coronavirus imagery." If the struggle between Eros and Thanatos is a core part of the human psyche, then this very classical theme is literally incarnated by corona porn, a present-day reworking of the danse macabre. These fatal attractions are some of the more revelatory aspects of the pandemic zeitgeist.

This porn-meets-pand[...] one to consider an a[...] recently unearthed by [...] storage unit in Philade[...] 150 works on paper by a presumably self-taught artist. The works fall into distinct groups—pencil drawings that are often sexual jokes, explicit watercolor scenes, and drawings on mimeograph paper.

Clues to the identity of the artist and the timeframe in which the works were made are embedded in the materials. The ledger paper and safety protocol forms that presumably he used as a support bear the letterhead of the well-known Philadelphia chemical manufacturing company Rohm & Haas, established in 1909. A partially affixed mailing label on the back of one of the drawings gives a Philadelphia address and indicates "foreman" as the addressee. The date 1955 is written on the back of another drawing. The clothing and hairstyles depicted seem to date from the 1940s and 1950s. A search in the company's archives turns up a staff photograph from 1931 listing numerous foremen who might be the author of this erotic cache.

The extraordinary oeuvre of the Philadelphia Foreman is a revelatory repository of midcentury male desire and sexual anxiety. The works are notable for their ambitious draftsmanship and vernacular details of middle-class American life. The Foreman lavished particular attention on clothing and interiors—his scopophilic pleasure was not only focused on the act of heterosexual coitus. He clearly loved visual puns and irreverent phallic jokes that seem far racier than the "Tijuana Bibles" of the 1940s and anticipated such populist "vulgar" 1960s magazines as Sex to Sexty. Almost certainly made for his own personal amusement and titillation, the Philadelphia Foreman's erotic drawings are a rare and fascinating time capsule of American folk porn.

How to Sign Your Name with Confidence

The chemist Otto Röhm was one of the first scientists to develop an acrylic form of glass, and his namesake company brought the product to market in 1933 under the name Plexiglas. Rohm & Haas in Philadelphia was the first to mass manufacture this revolutionary new material—it was notably found to have strategic utility in outfitting military aircraft canopies, bomber noses, submarine periscopes, and gunner turrets. It is easy to imagine how an iconic image of a woman plant worker (à la Rosie the Riveter) polishing a very phallic Plexiglas windshield at the Rohm & Hass factory in 1940s could have entered the erotic imaginary of the Philadelphia Foreman! Plexiglas was the lifeblood of Rohm & Haas—in the decade after the war, it became one of the most emblematic materials of the US commercial landscape. Illuminated, backlit, and available in a rainbow array of hues, Plexiglas store signage became the signifier of the "long boom" of US capitalism throughout the 1950s and 1960s. Rohm & Haas took out numerous magazine advertisements touting their product. One print ad from a 1955 issue of the industry magazine Chain Store Age featured the tagline How to sign your name with confidence—use Plexiglas!

Confidence—and conversely a lack thereof—are threads that run throughout the Philadelphia Foreman's oeuvre. His drawings can be classified in two opposing categories: the confident (straightforward depictions of the fulfillment of heteronormative desires) and the impotent (images conjuring sexual fears, oedipal drama, impotence, and phallic inadequacy). A consideration of the general social context of the time, as well as Rohm & Haas's entwinement with the US military industrial complex during the war, deeply informs our ability to speculate on the meaning of the trove of drawings. Beyond reflecting one man's fantasies, they offer a snapshot of a seemingly archetypal American male psyche and how it was shaped by society, his particular industry, and other factors.

The shadow of World War II and its ideological effects on the US middle and working classes is evident. For example, a drawing of a woman in a kimono squatting and flashing her hairy vulva immediately conjures a wartime erotic archetype—the kimono telegraphing exoticism and sexual titillation to the American GI. In the same way the external existential threat of coronavirus connects to our erotic imaginaries, so with Americans during the war in the Pacific. The Foreman was fastidious about every detail, from the elaborate greenery that surrounds the raven-haired Japoniste model to the floral pattern on her silk robe and her traditional tabisocks and getasandals. Could it have been that our Foreman was not a hero on the front lines, but instead stuck at home working in Philadelphia, surrounded by strong women on the factory floor, such that the anxieties underpinning the drawings reflect wartime mental distress? As Freud suggested in his 1915 paper "Thoughts for the Times of War and Death," "the individual who is not himself a combatant—and so a cog in the gigantic machine of war—feels bewildered in his orientation, and inhibited in his powers and activities."[2] Impossible to know for certain, but in at least half of these drawings, tropes of anxiety and disempowerment, even in the jokey vein, seem to conform, per Freud's musings, to the portrait of the traumatized noncombatant who is a mere cipher of the war industry.
To continue in a Freudian vein, one of the most revelatory aspects of the drawings are the jokes that appear in both the "confident" and "impotent" categories. The motif of a picture-within-a-picture is a recurring vehicle for delivering the visual "kicker." These "tendentious jokes"—what Freud defined as humor laced with sexual or hostile content—appear in the backgrounds of some of the most straightforward heteronormative fantasy scenes focused on heterosexual coitus, lesbian couples, or group sex, and often subvert the licentious action. The background-wall pictures include a lewd portrait of "Mom" with exaggerated breasts and bush and "Dear Old Dad" with a giant, dripping erection. Could these hypersexualized parental figures looming over otherwise titillating fantasy scenarios indicate possible Oedipal rage? It seems significant that the main action in both of these particular drawings has the woman on top, dominating her male sex partner and obscuring his face. In fact, in almost all of the full-color drawings in the "confident" category, women are on top! Could these drawings be some kind of unconscious avowal of the familial roots of the Philadelphia Forman's own sexual anxieties? In the "impotent" camp of his production, the cartoonish

sexual jokes are entirely rooted in castration anxiety and penis envy. Whether the broken bone(r) in his X-ray drawings, the woman who ate a dick, or the phallic bathroom competition between father and son, the artist transforms primal fears and hostilities into the very subject of the joke.

Could it be that "confident" and "impotent" are two sides of the same coin? There is a clear interdependency between the Foreman's depiction of pure sexual fantasies and the crude jokes, in that both seem to serve a cathartic end. Who wants a dad with a dick that big? Who wouldn't want to castrate him, and who, possessing a broken dick, wouldn't compensate with heteronormative scenes of big dicks and big-breasted women? The drawings are rooted in their specific time and place, yet they remain resonant to us contemporary viewers because they corroborate an anxious condition that so many of us have been stuck in since the postwar period. Beyond their value as rare examples of midcentury folk porn, the Philadelphia Foreman created an enduring snapshot of the human condition.

Private Vice: Folk Porn or Outsider Erotica?

Webster defines folk art as "the traditional decorative or utilitarian art of the people that is often an expression of community life and is distinguished from academic or self-conscious or cosmopolitan expression."[3] The catchall "outsider art," used to describe the work of self-taught or untrained artists, is a more contentious term, as it generally implies an assumption regarding the artist's compromised social or psychological status—mental illness, developmental disability, autism, self-imposed isolation, or incarceration. Sometimes it is used for work made by children. Such nomenclature as naive art, visionary art, primitive art, and art brut—that last Jean Dubuffet's coinage, which he described as "burning mental tension, uncurbed invention, and ecstasy of intoxication, complete liberty"—is often interchangeably used for artistic practices falling outside the boundaries of mainstream fine art.

Beyond the assumption that the Philadelphia Foreman was an autodidact, making his drawings to rouse his private vices, it is a tricky if not superfluous exercise to classify his production in the folk or outsider camp. The corpus of drawings has hallmarks of both outsider and folk art—flattened forms, obsessive detailing, pictorial directness, distorted perspective, and naive rendering as well as legible cultural markers that firmly ground the works in a specifically American milieu. But one might argue that the Philadelphia Foreman's art was already folk art, given that porn is inherently a folk genre—a traditional form of visual culture, shared among a given community, that fulfills common needs and values. Porn is utilitarian. As the radical sexologists Drs. Phyllis and Eberhard Kronhausen argued from the 1950s onward, explicit material is psychologically and socially crucial for public health. Their 1959 book Pornography and the Law: The Psychology of Erotic Realism and Pornography maintained that explicit visual materials such as pornography and what they called "erotic realism" served as a "social safety valve" to counter the detrimental effects of sexual repression, especially in puritanical US culture. While pornography was illegal in the

United States until a series of legal cases gradually loosened obscenity laws in the late 1950s and 1960s, porn has been omnipresent in modern Western culture, even when hidden from plain sight.

It was in the Enlightenment that the category of pornography emerged as a volatile and potentially dangerous entity that required institutional constraint. Lynne Hunt writes in her book The Invention of Pornography, 1500–1800 (1993), "Pornography was a regulatory category that was invented in response to the perceived menace of the democratization of culture. Porn's development as a category was always one of conflict and change, it was a cultural battle zone. Pornography came out of the demi-monde of heretics, free thinkers and libertines."[4] I would assert that the Philadelphia Foreman's secret oeuvre is a vital artifact of this seditious branch of folk visual culture.

Erotica has long been kept under lock and key —sequestered for the private consumption of men as well as to "protect" polite society. In Europe, "obscene" collections assembled by aristocrats eventually were absorbed into repositories like the Secretum section of the British Museum and the Enfer collection at the Bibliotheque Nationale in Paris. The clandestine cabinets that conserve the contents of the "hell" archive house not only licentious literature from the sixteenth through the nineteenth centuries, but blasphemous prints and torrid engravings like the phallic send-ups of Archimboldo included in Les fouteries chantantes ou Les récréations priapiques des aristocrates en vie, en vit par la muse libertine (1791).[5] Drawing is not the primary mode of expression associated with contemporary pornographic visual culture, but explicit drawing has a long history that is entwined with the institutional censoring and control of erotic material. The dirty etchings of Thomas Rowlandson (1756–1827), a Georgian-era forerunner of our Philadelphia Foreman, are prime examples of illustration in the service of eros. Rowlandson's work erred toward the satiric, in keeping with the conventions of British caricature; his more explicit works were produced for discreet aristocratic audiences and often combined politically tinged or anti-clerical parody with titillating depictions of couples in flagrante delicto. Rowlandson's signature mix of bawdy humor and libertine explicitness in an engraving such as The Concert (ca. 1810) is echoed in the sexual mockery in the Philadelphia Foreman's pencil drawings executed some two centuries later. Both artists deployed their drawing tools to skewer as well as inflame male desire.

The creation of work to titillate "private vices" has never been the exclusive domain of trained artists. Established by art historian and psychiatrist Hans Prinzhorn in the early twentieth century, the Prinzhorn collection in Heidelberg was among the first attempts to anthologize and promulgate art made by mental patients, and it influenced the work of countless modernists. Among the thousands of works Prinzhorn collected, many manifest sexually explicit themes. E. Paul Kunze (1860–ca. 1913) was a patient at a German asylum whose work in collage and drawing often portrayed his libidinal proclivities—exaggerating women's legs while cartoonishly rendering a man's erection in response to his fetish.

Confined to the Klingenmünster asylum, Katherina Detzel (1872–1941) created a life-size, genitally correct male doll out of her bedding in 1914. A single photograph survives of the artist-patient and her effigy. What motivated Detzel? "Is it an apotropaic effigy or a simple plaything? Magic or fetish? Nostalgic or ludic? Traumatic or mocking? Representation or misrepresentation?"[6] Joseph Schneller (1878–1943) was committed to an asylum in Munich, where he indulged his sadomasochistic sexual proclivities through meticulous colored-pencil drawings of violent bondage scenes and other extreme perversions. He filled every inch of the page with unsparing detail. Another master of horror vacui, Adolf Wölfli (1864–1930), is considered the "greatest of all psychotic artists."[7] Hospitalized for paranoid schizophrenia, Wölfli was a prolific draftsman whose ornate works evoked his hyper-ordered yet strange cosmology. He frequently included stylized vaginal forms that he called Vögeln (Swiss German for "little birds," slang for coitus).

1. Justin J. Lehmiller, "How the Pandemic Is Changing Pornography," Psychology Today, March 23, 2020, https://www.psychologytoday.com/us/blog/the-myths-sex/202003/how-the-pandemic-is-changing-pornography.
2. Sigmund Freud, "Thoughts for the Times on War and Death," in The Standard Edition of the Complete Psychological Works of Sigmund Freud, trans. James Strachey, in collaboration with Anna Freud, assisted by Alix Strachey and Alan Tyson (Vintage, 1999), 14:275.
3. See https://www.merriam-webster.com/dictionary/folk%20art.
4. Lynn Hunt, The Invention of Pornography, 1500–1800: Obscenity and the Origins of Modernity (Cambridge, MA: Zone Books/MIT Press, 1993).
5. https://gallica.bnf.fr/ark:/12148/bpt6k851124m/f24.item
6. Allan S. Weiss, "Prinzhorn's Heterotopia" in The Prinzhorn Collection: Traces Upon the Wunderblock (New York: Drawing Center, 2000), 54, available at https://issuu.com/drawingcenter/docs/dp_7_prinzhorn_collection_reduced.
7. Parallel Visions, 271.

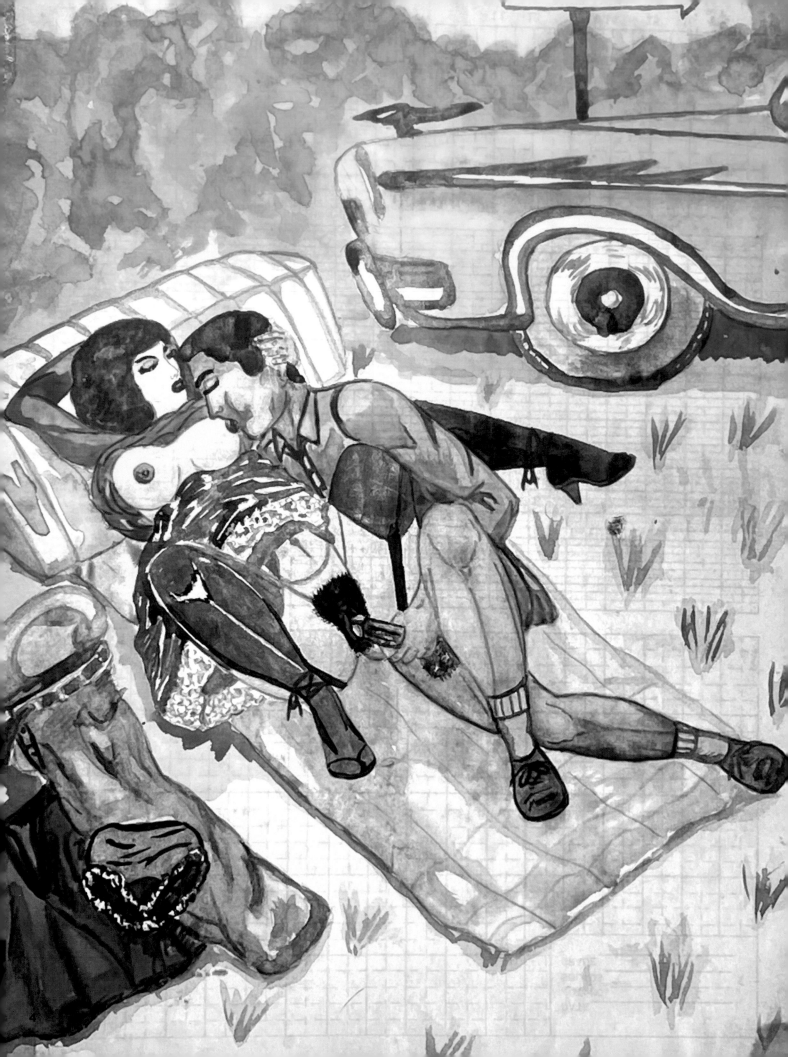

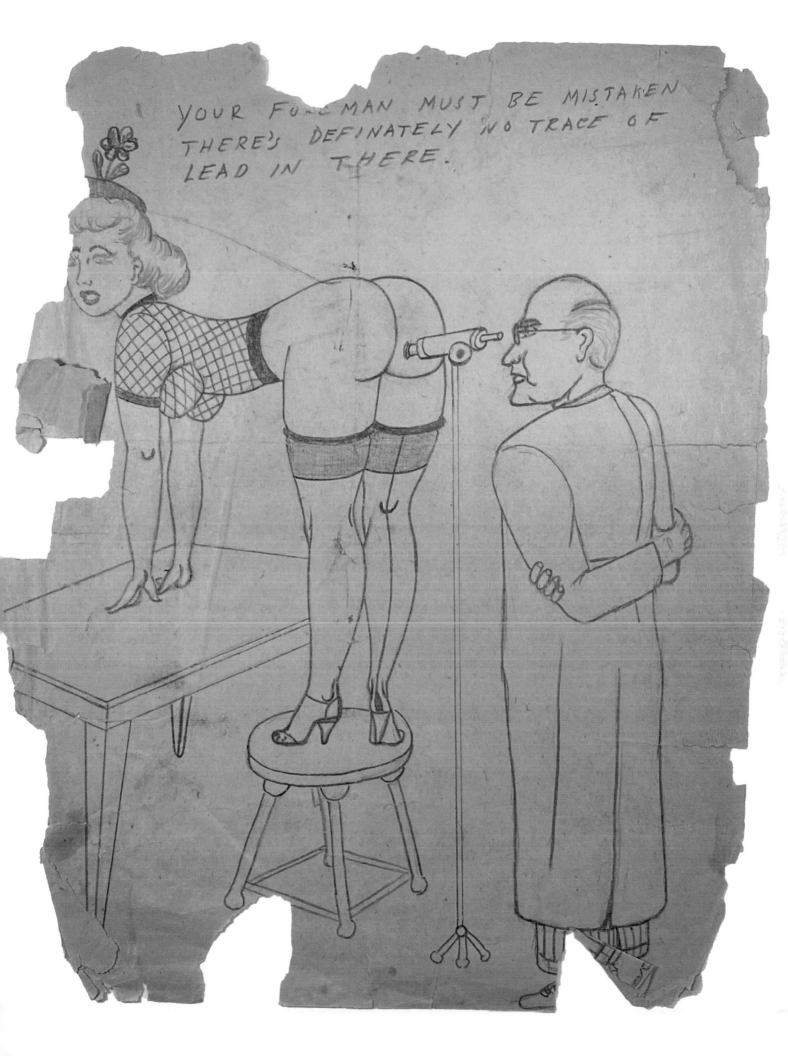

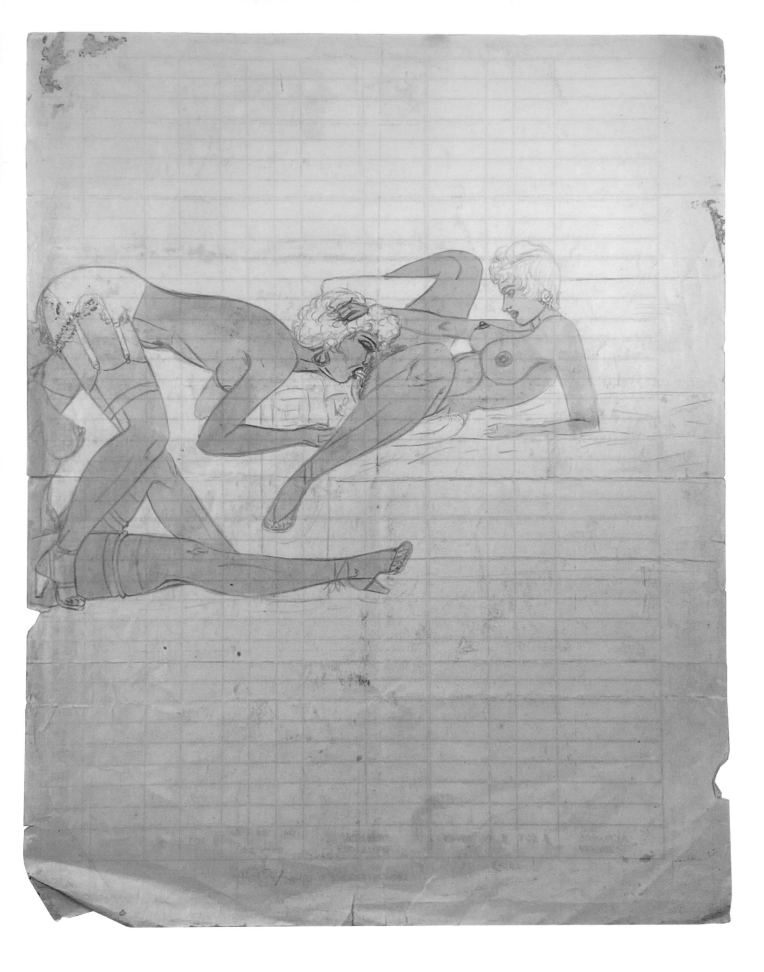

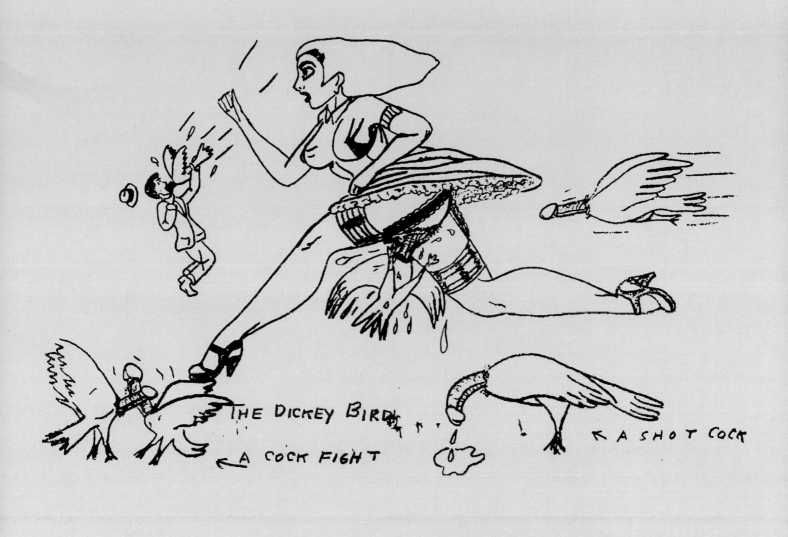

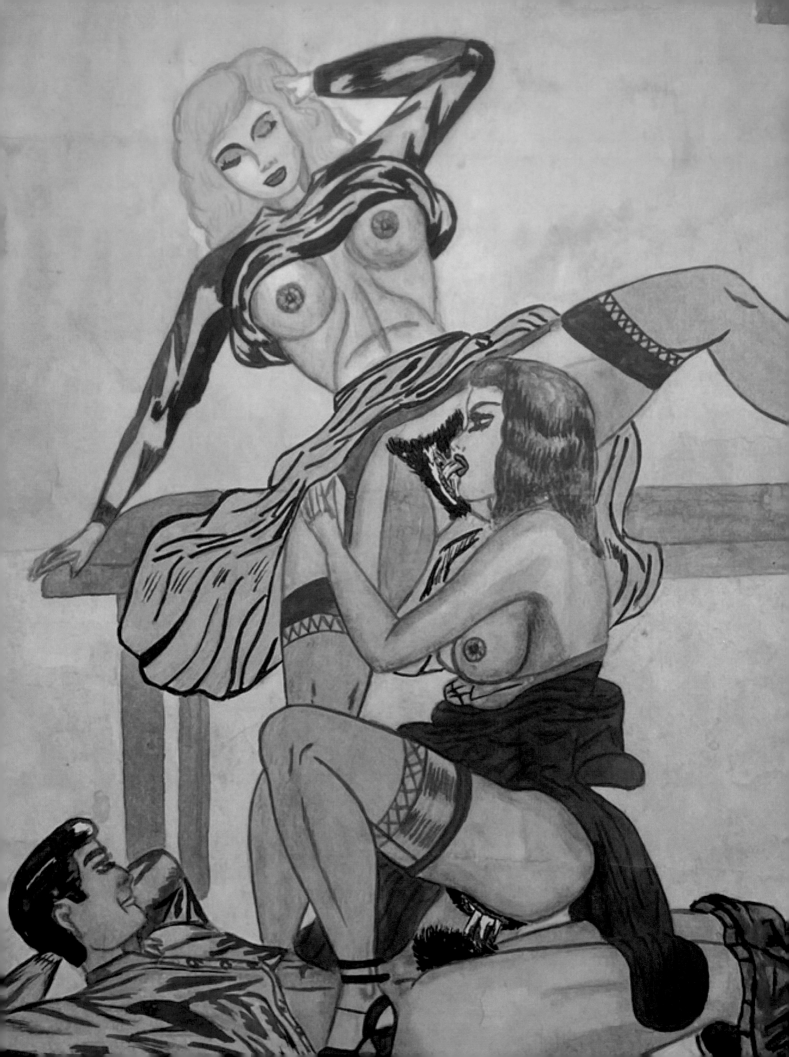

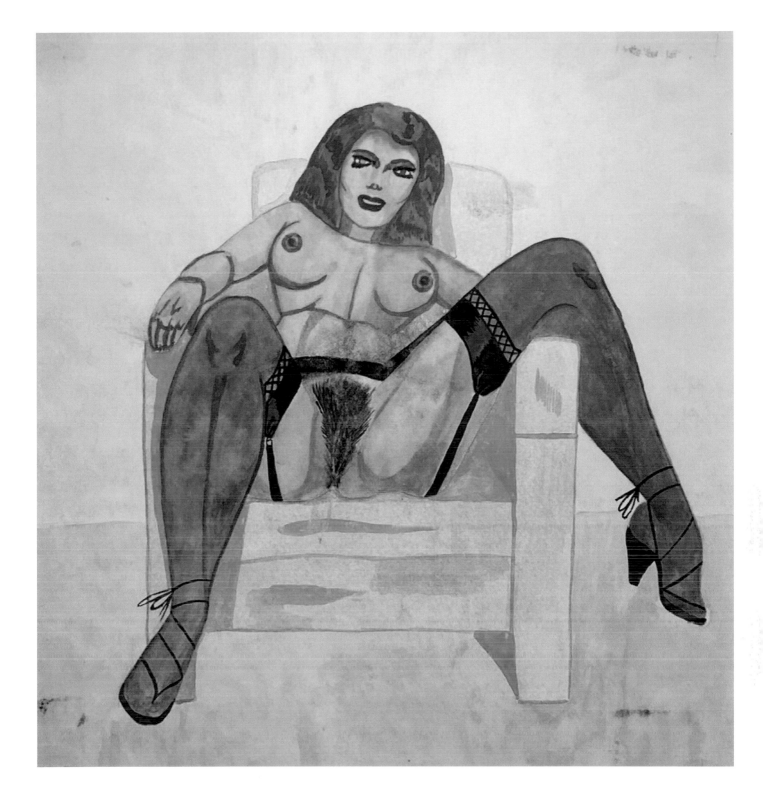

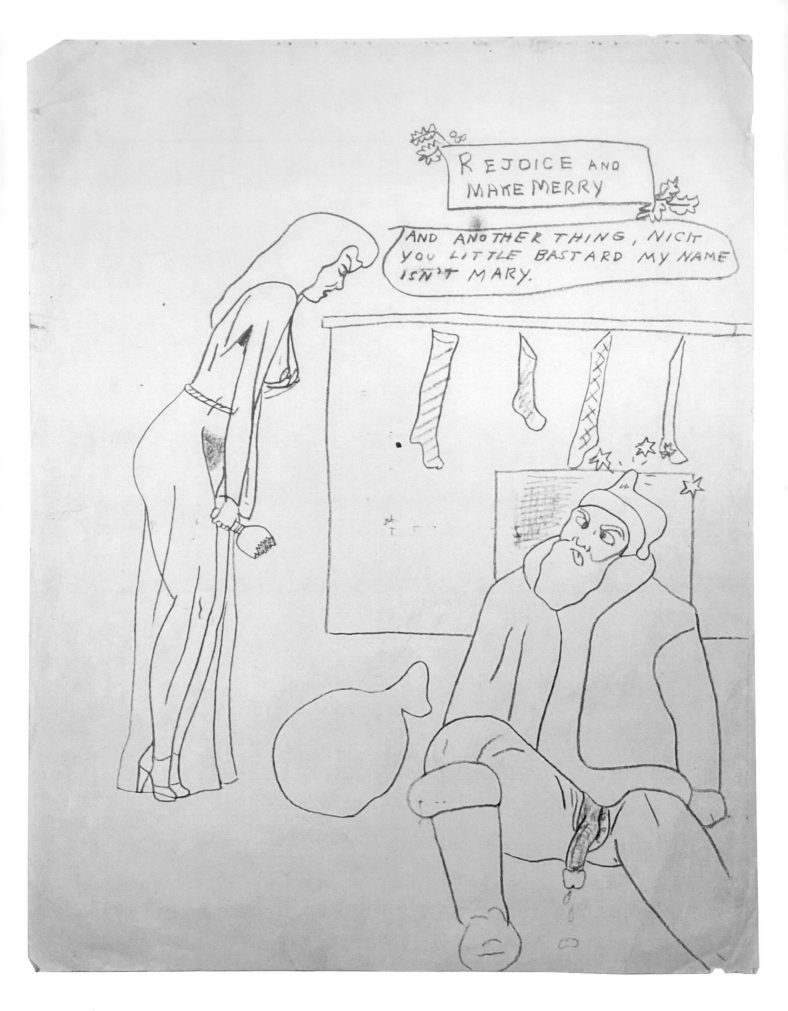

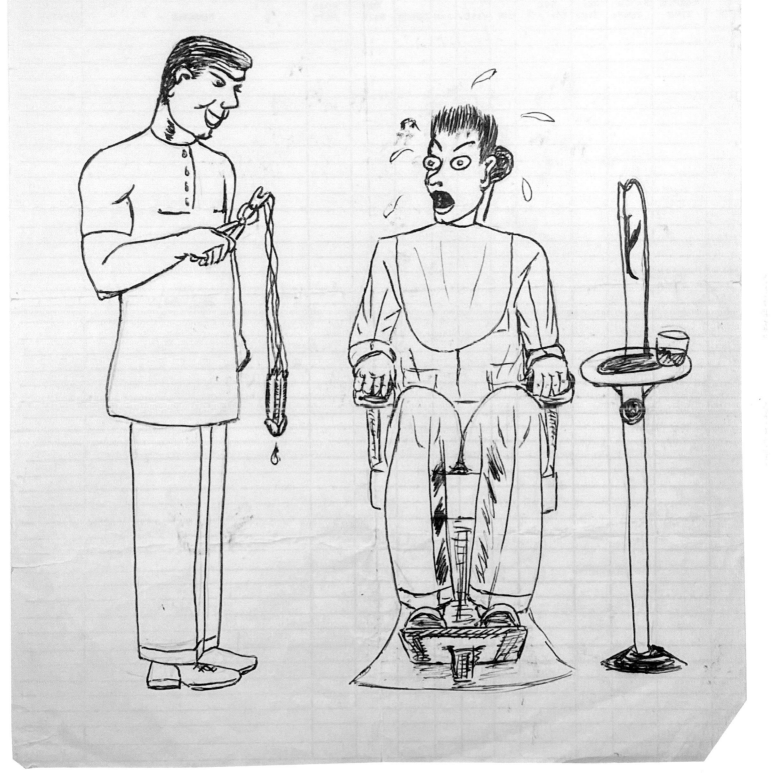

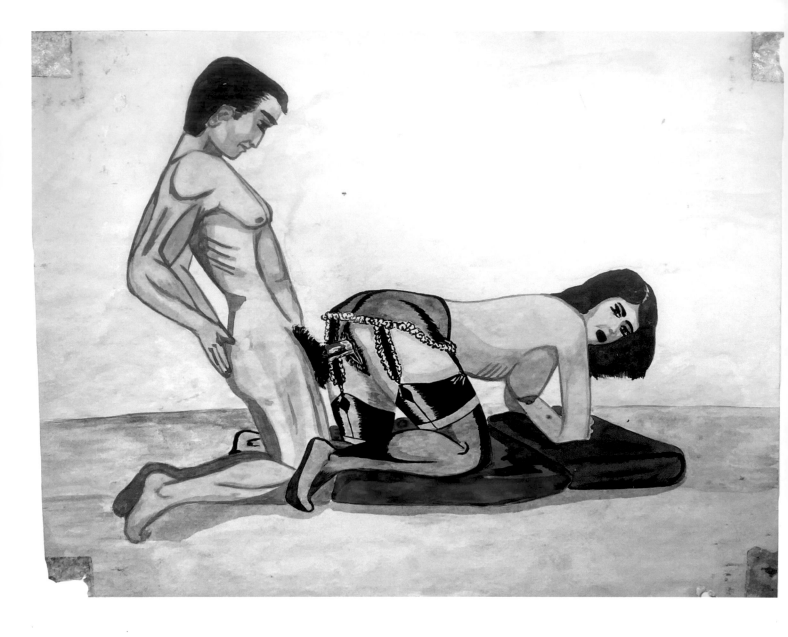

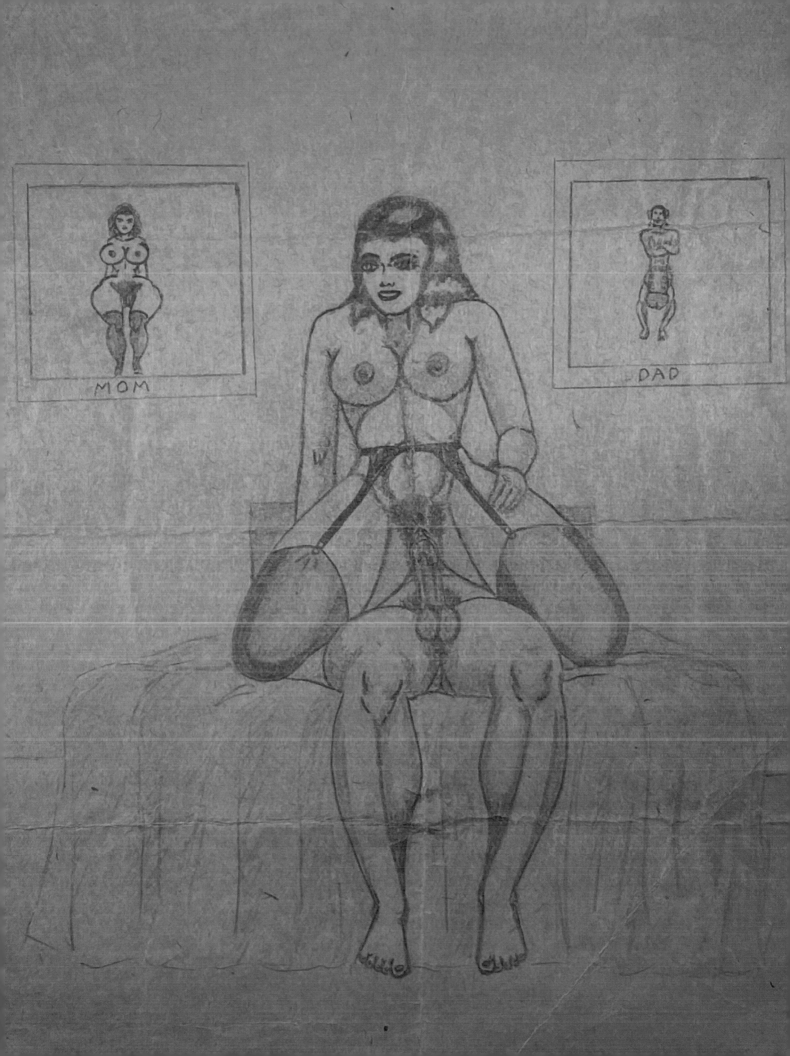

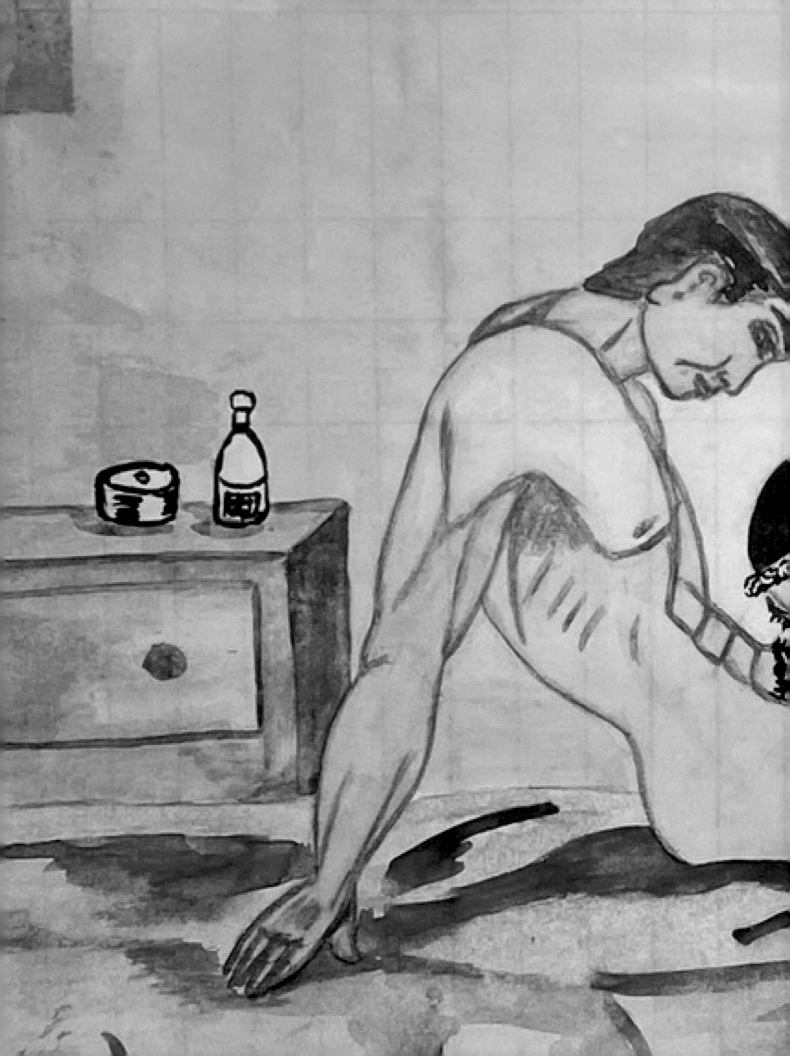

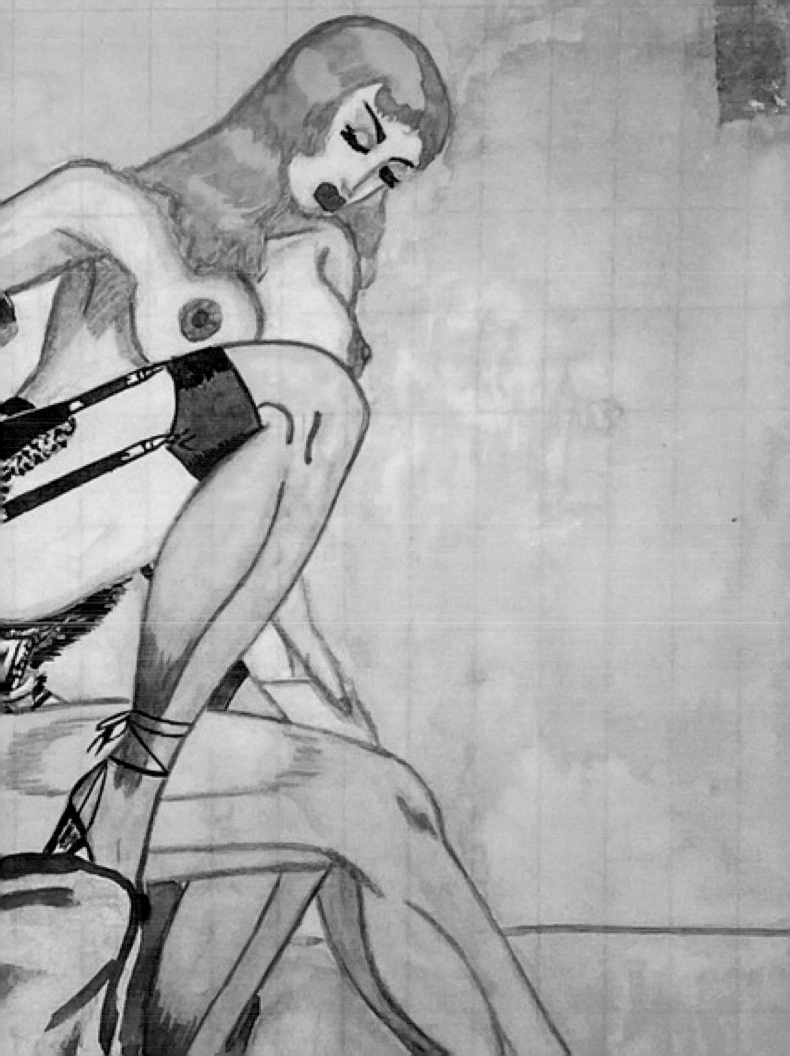

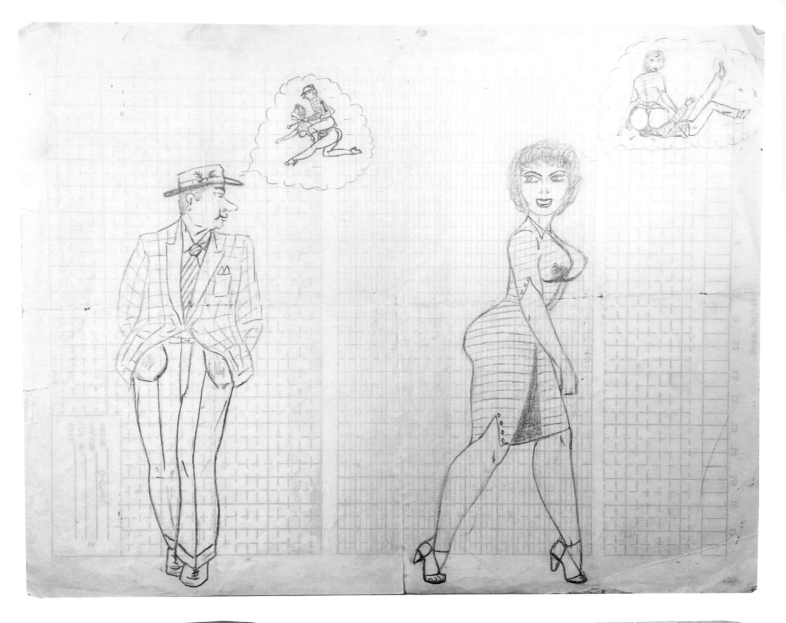

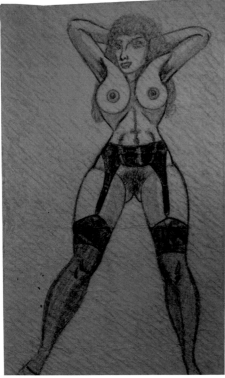

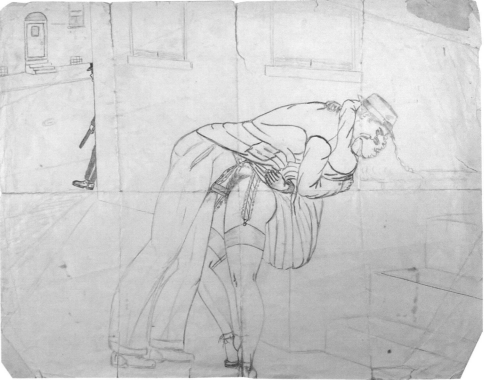

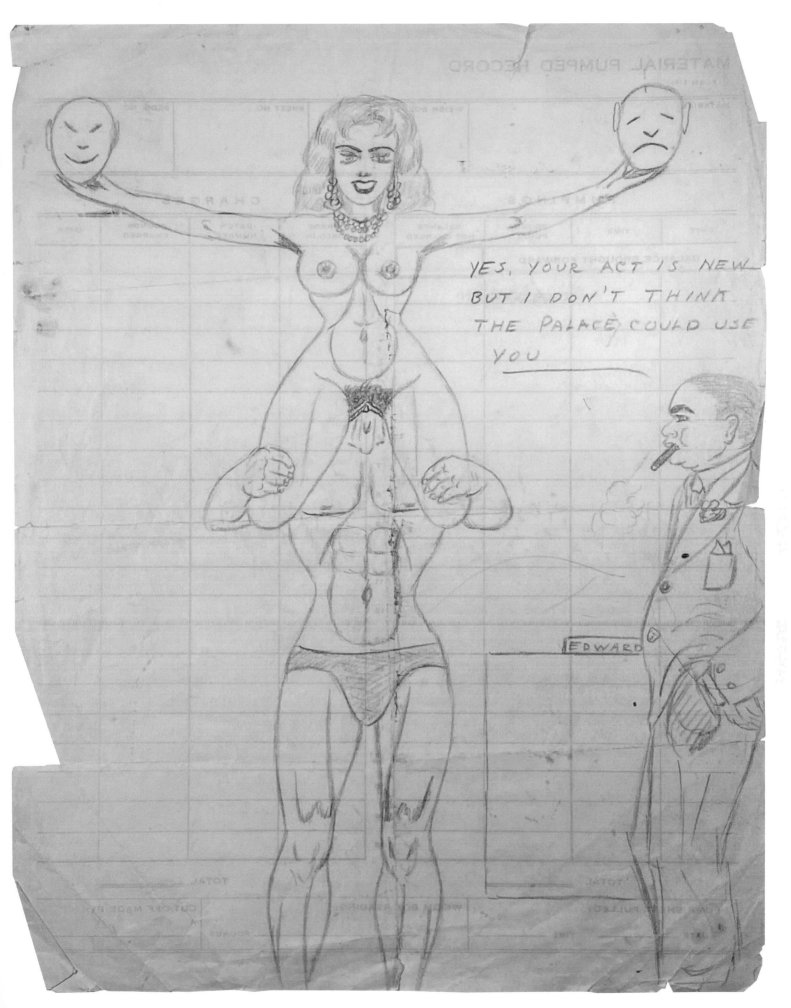

17

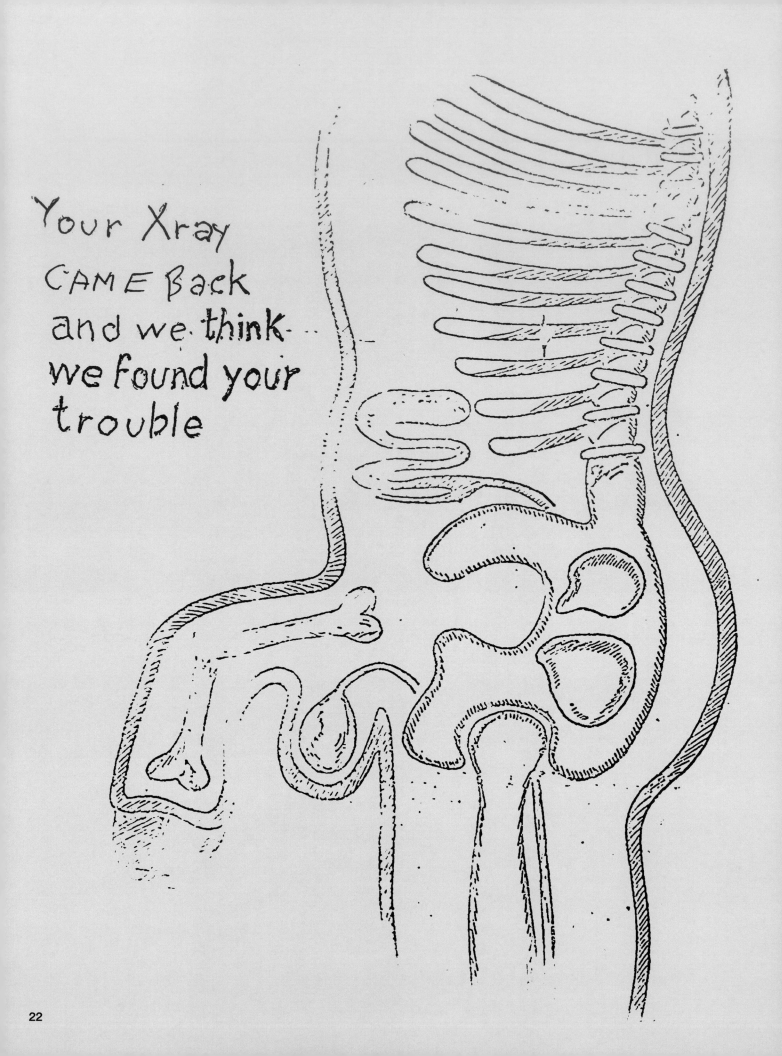

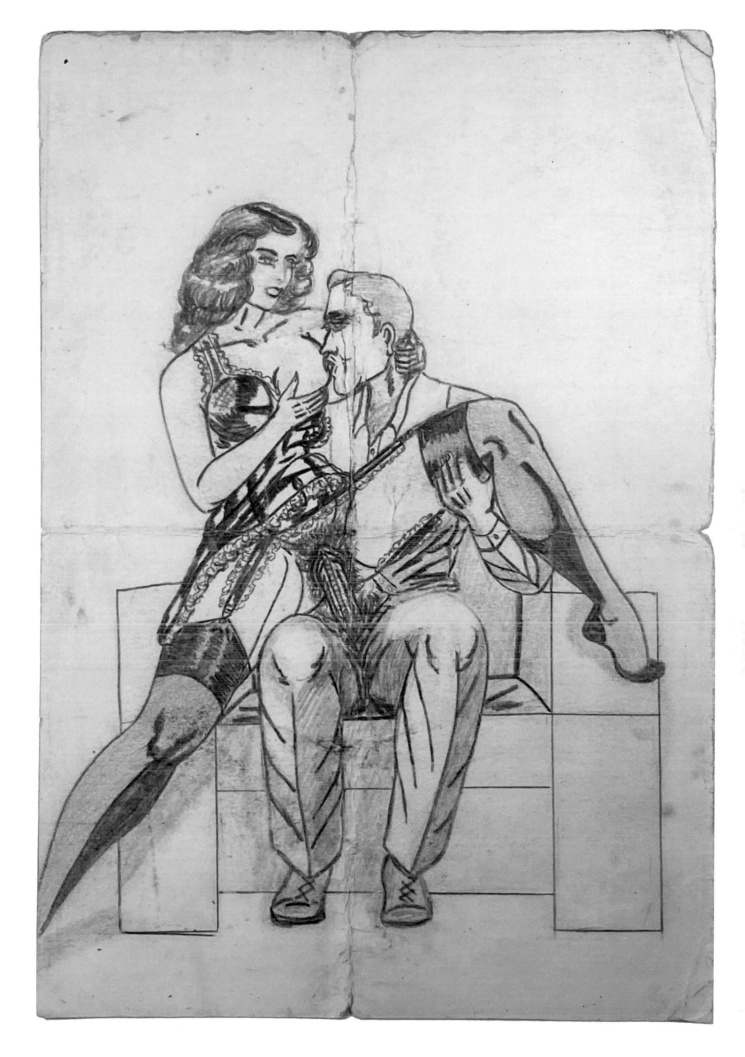

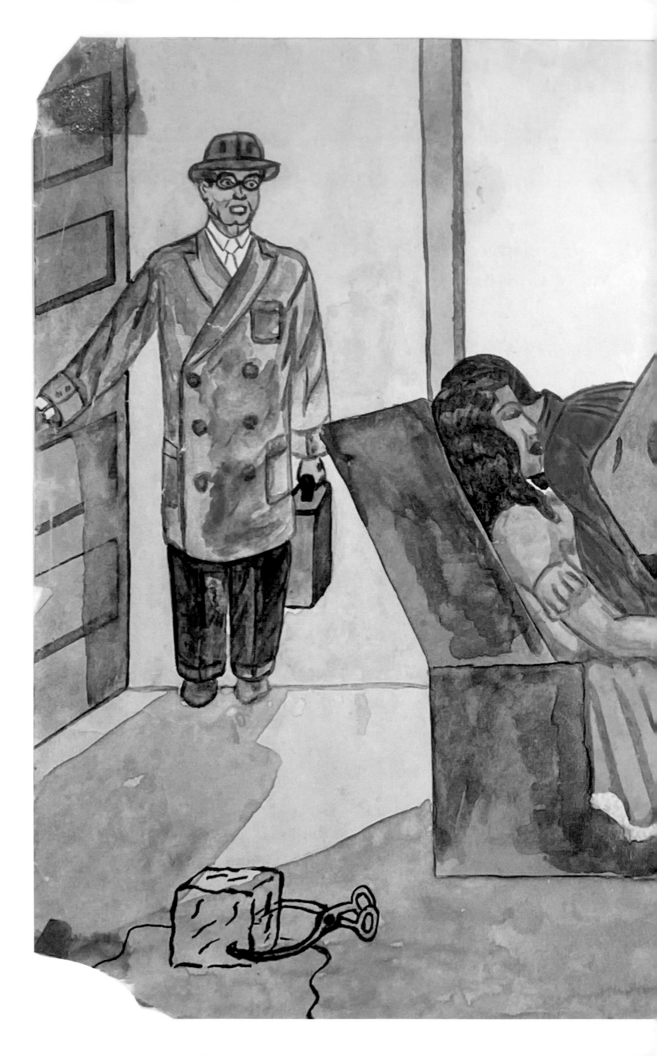

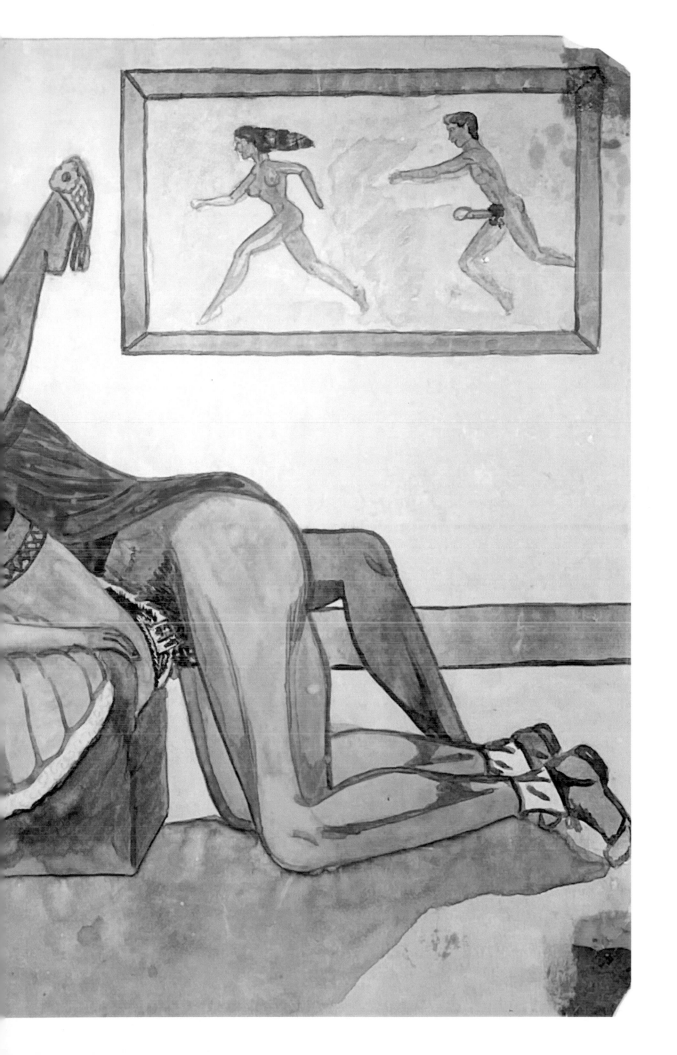

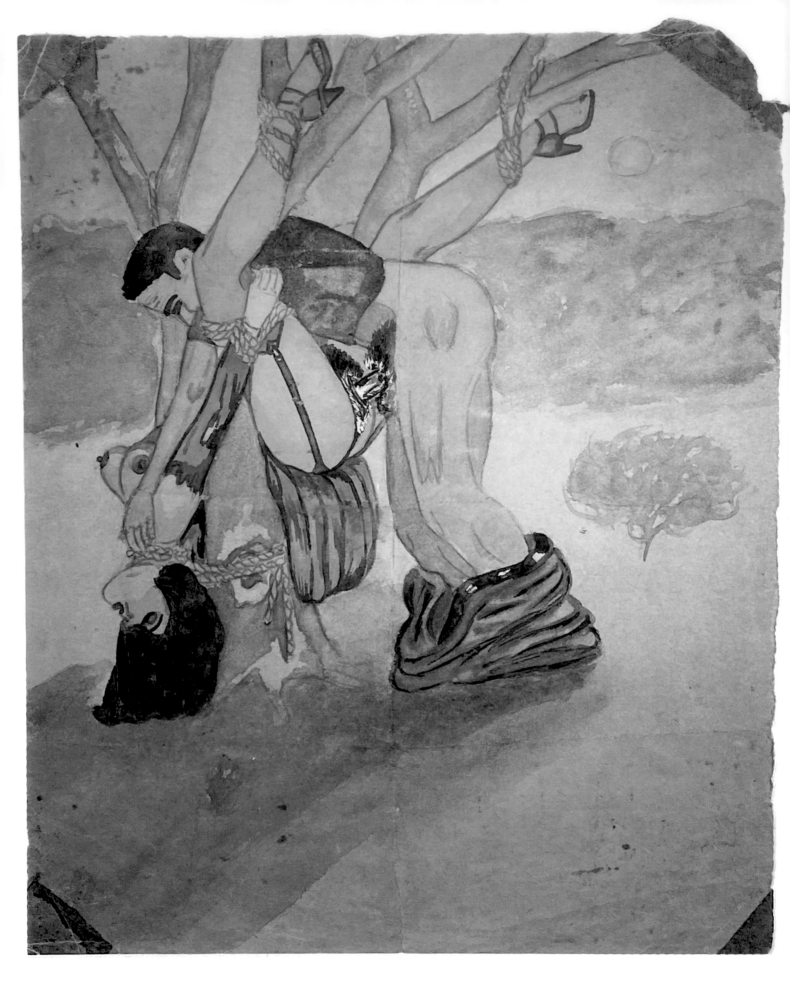

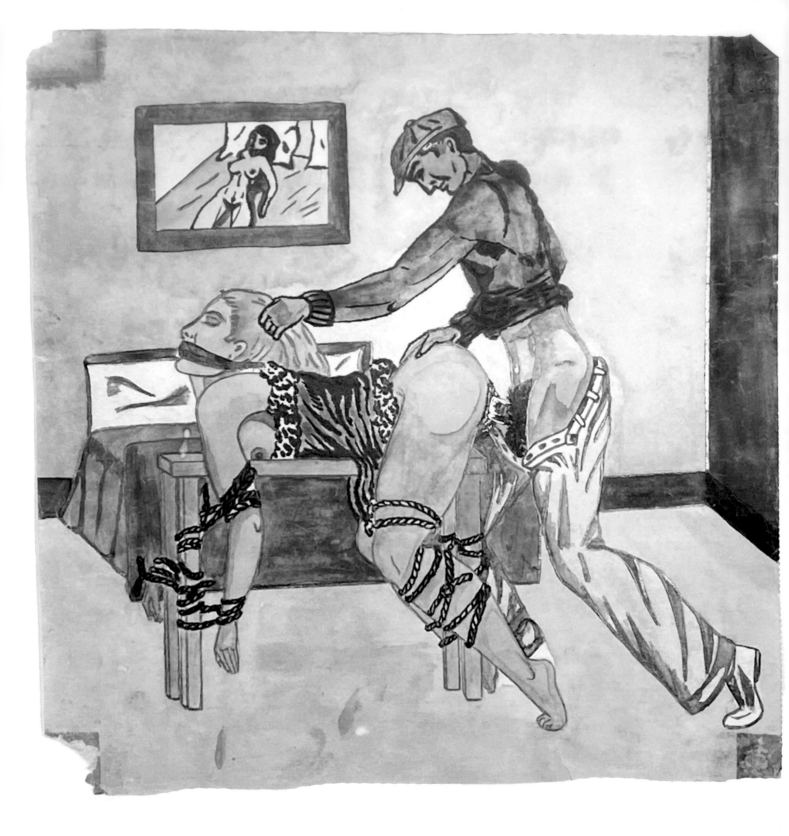

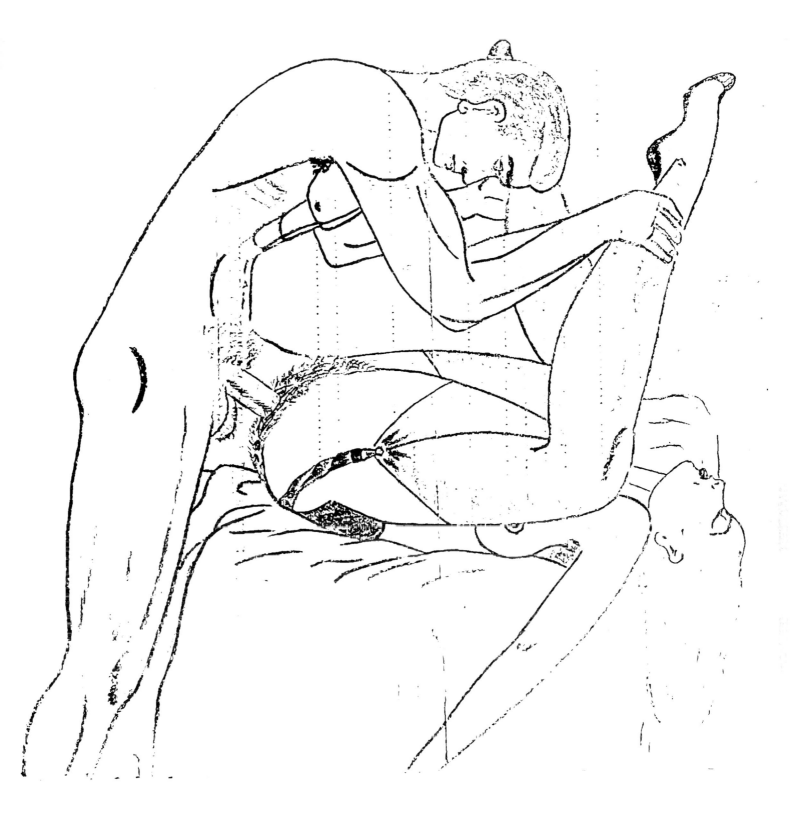

Who are then taken to the sunburn room where
they are indoctrined with the few simple
rules of the club the first of which is that
clothing must fully cover the anatomy or
not at all—

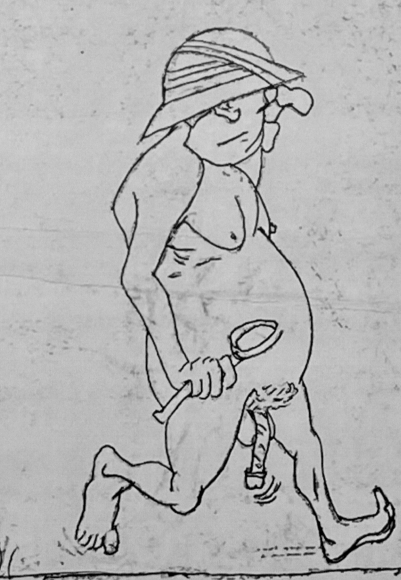

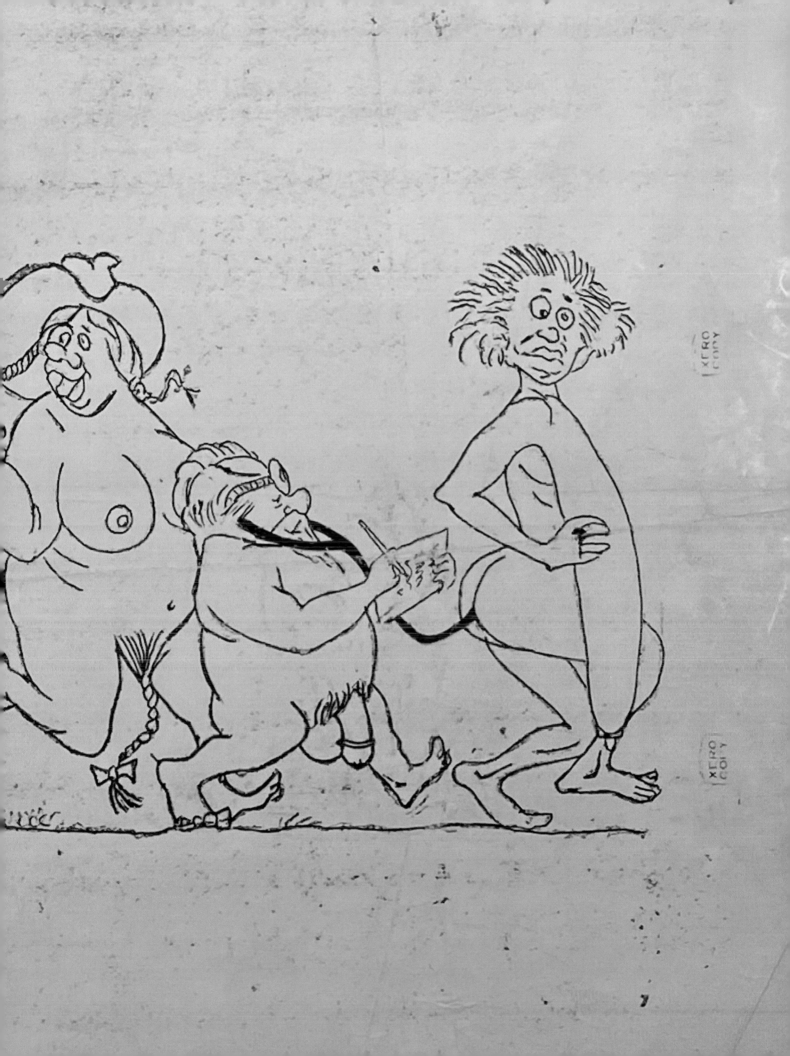

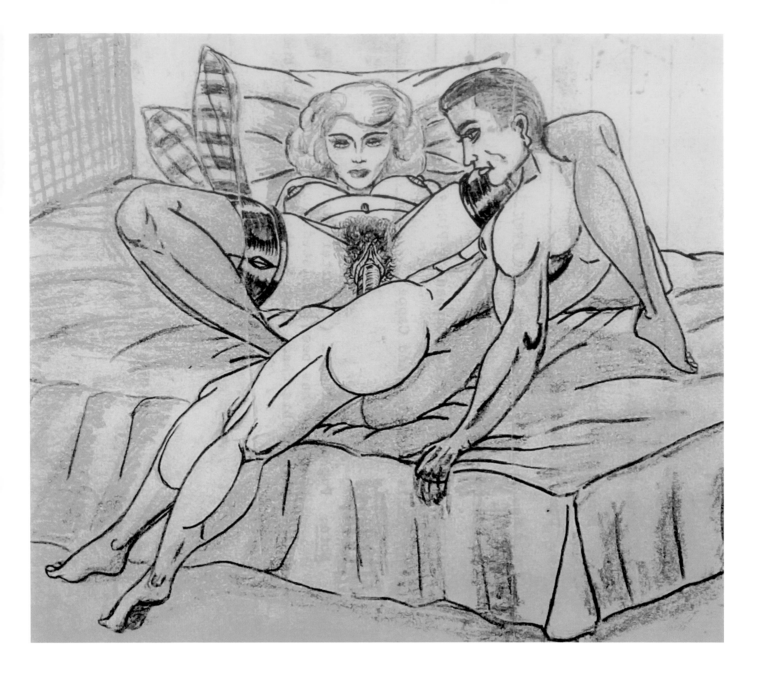

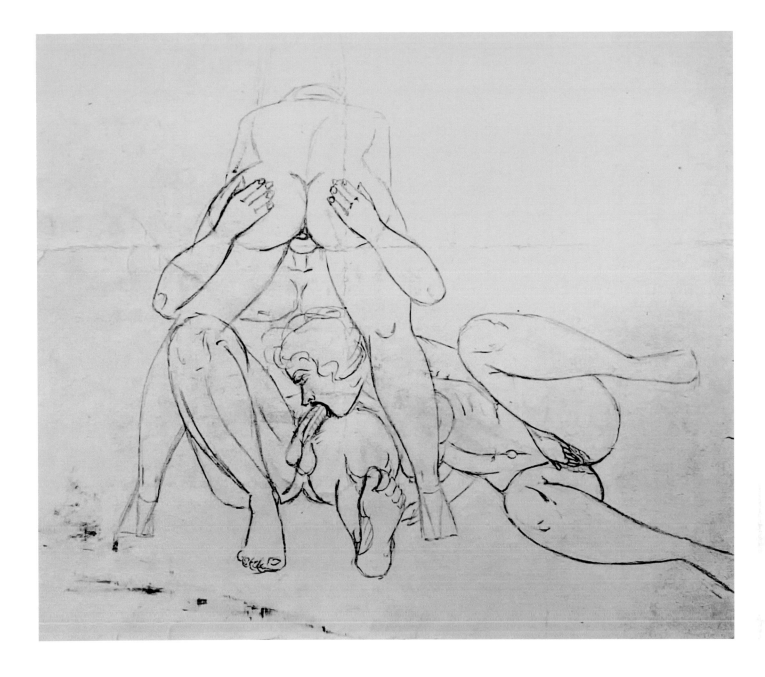

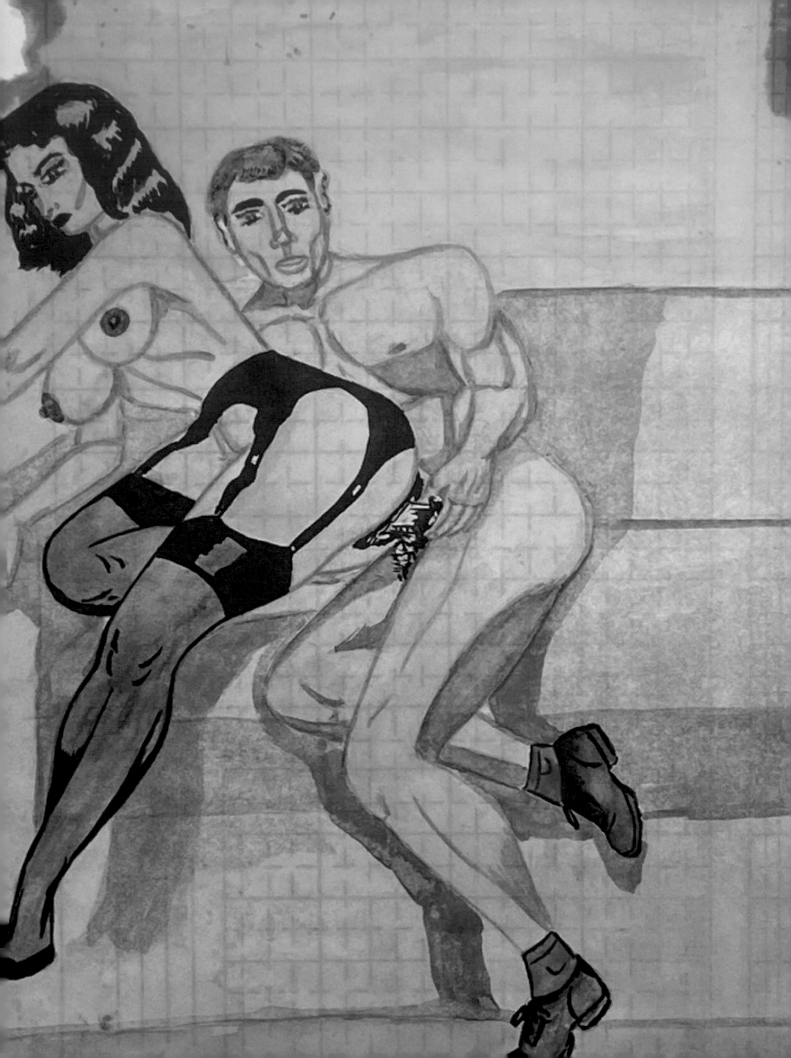

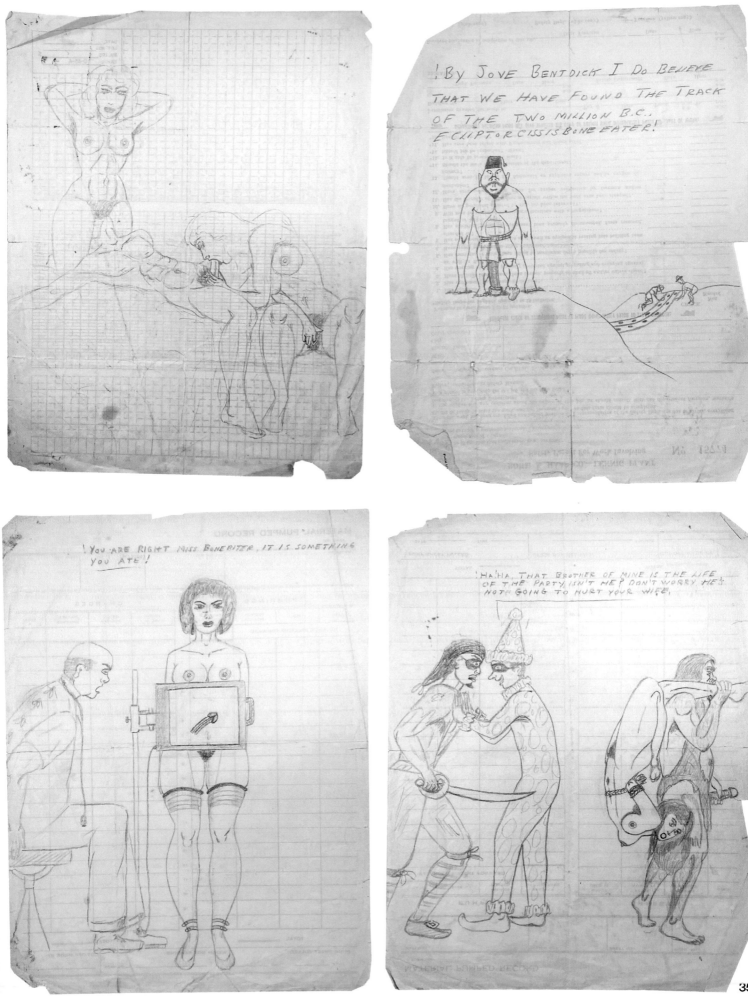

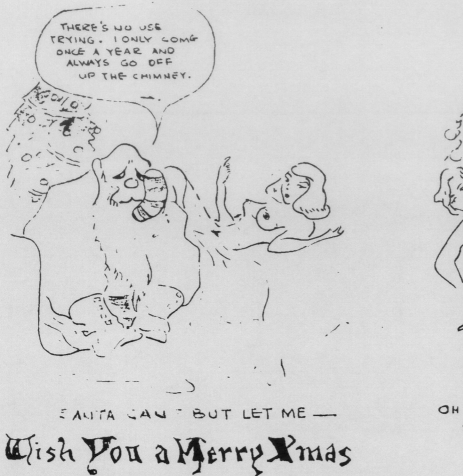

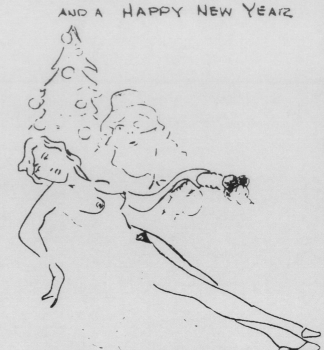

A MERRY CHRISTMAS AND A HAPPY NEW YEAR

SANTA CAN'T BUT LET ME —

Wish You a Merry Xmas

OH SANTA CLAUSE! AND YOUR SUCH A LITTLE FELLOW

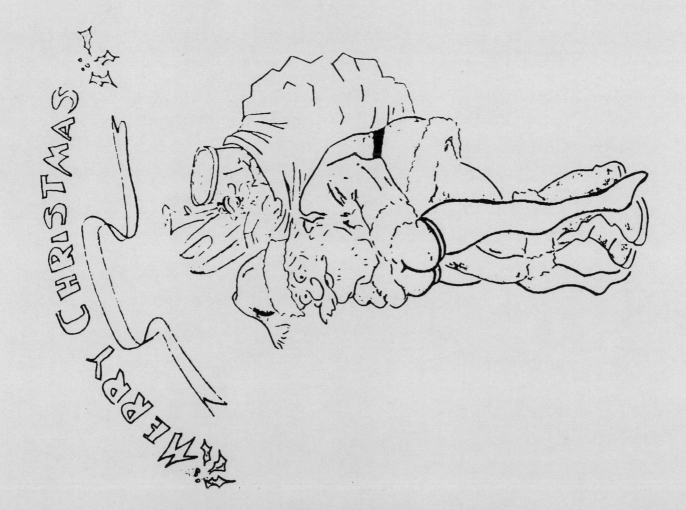

HAPPY CHRISTMAS

BUT DOCTOR WEAK EYES, I DON'T THINK THAT
THIS IS HIS APPENDIX, YOU BETTER
PUT IT BACK

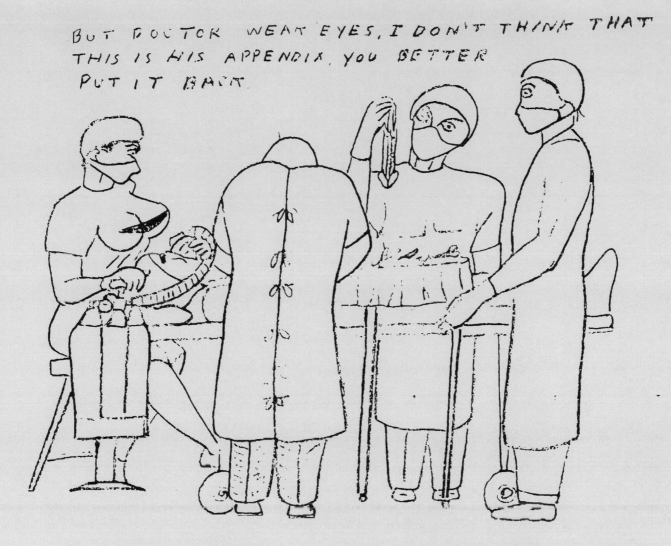

SHE MARRIED THE GUY
FROM THE PAWN SHOP.

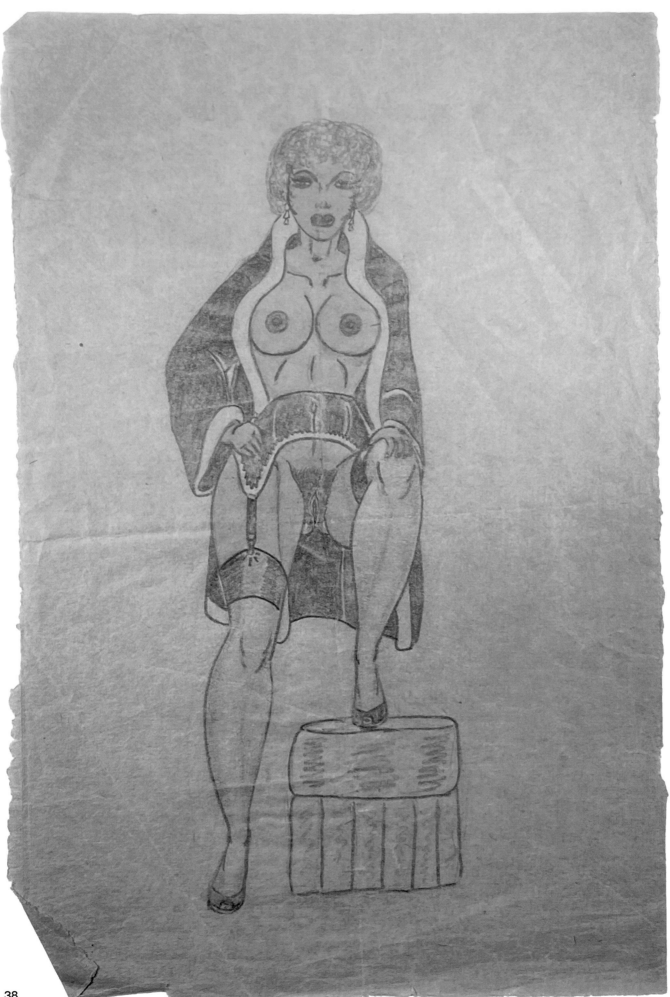

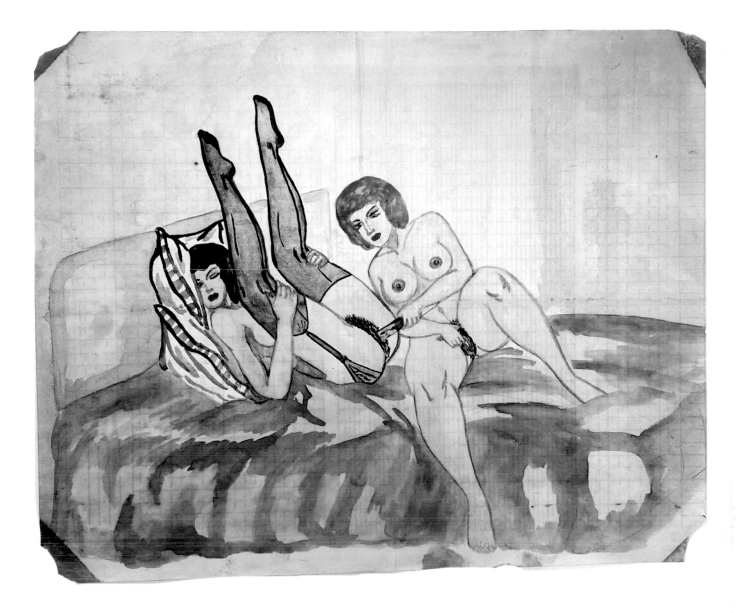

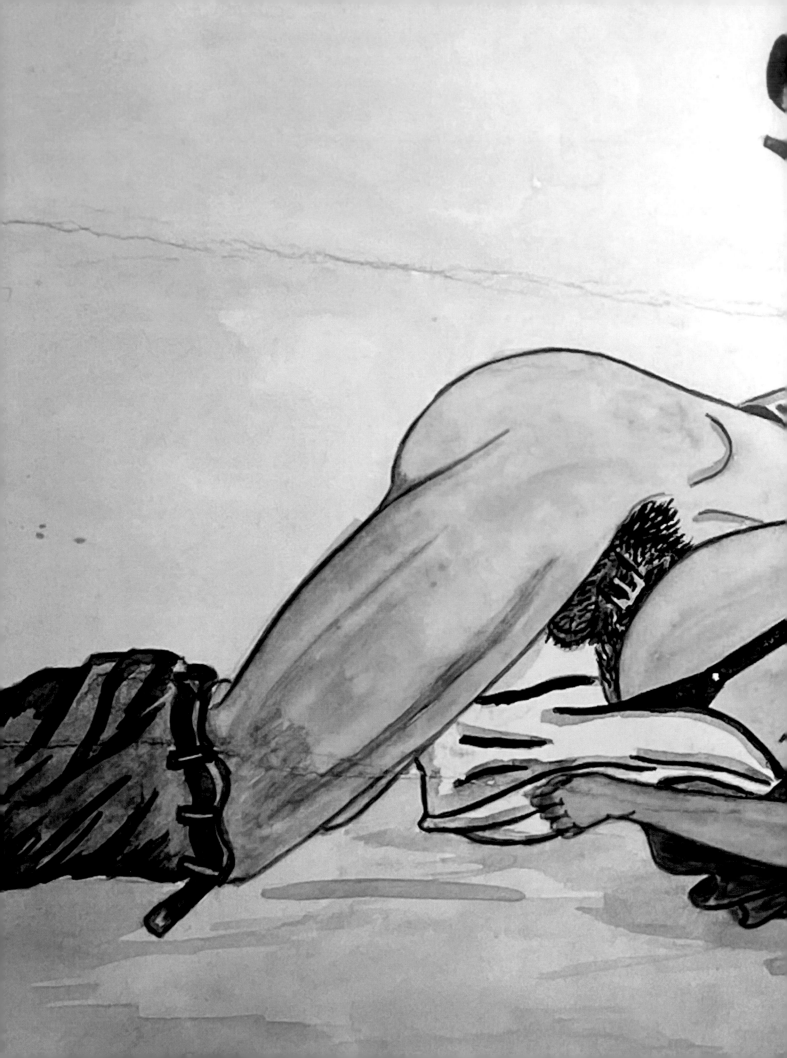

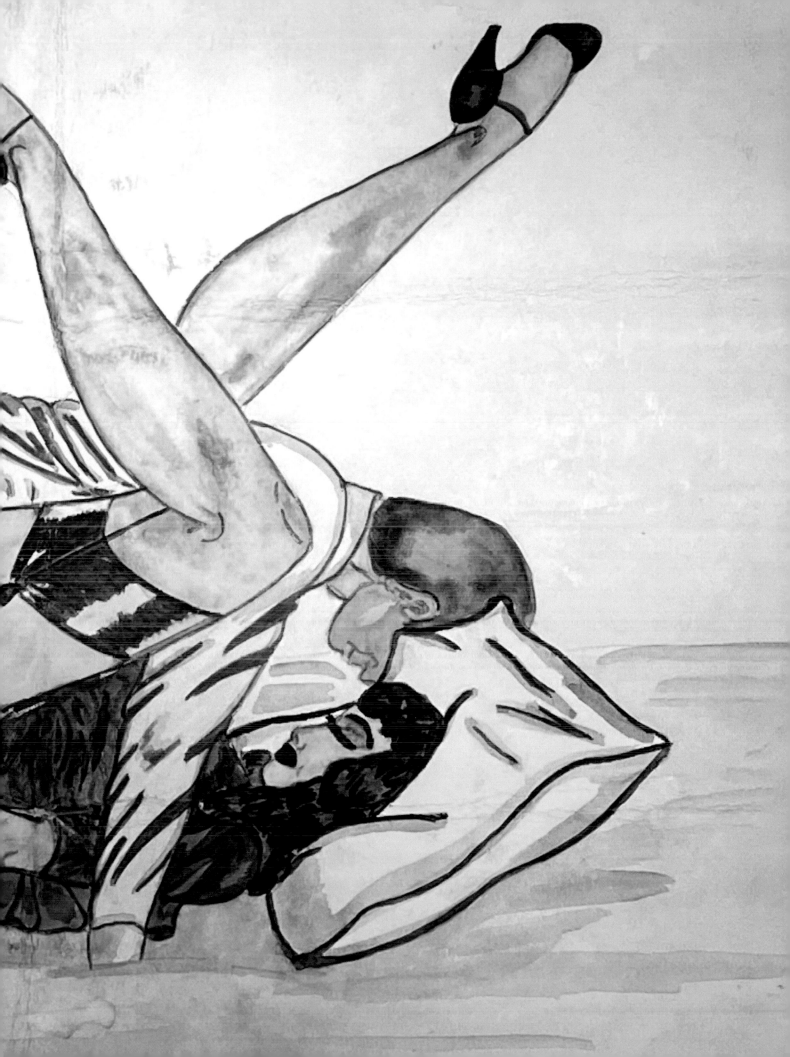

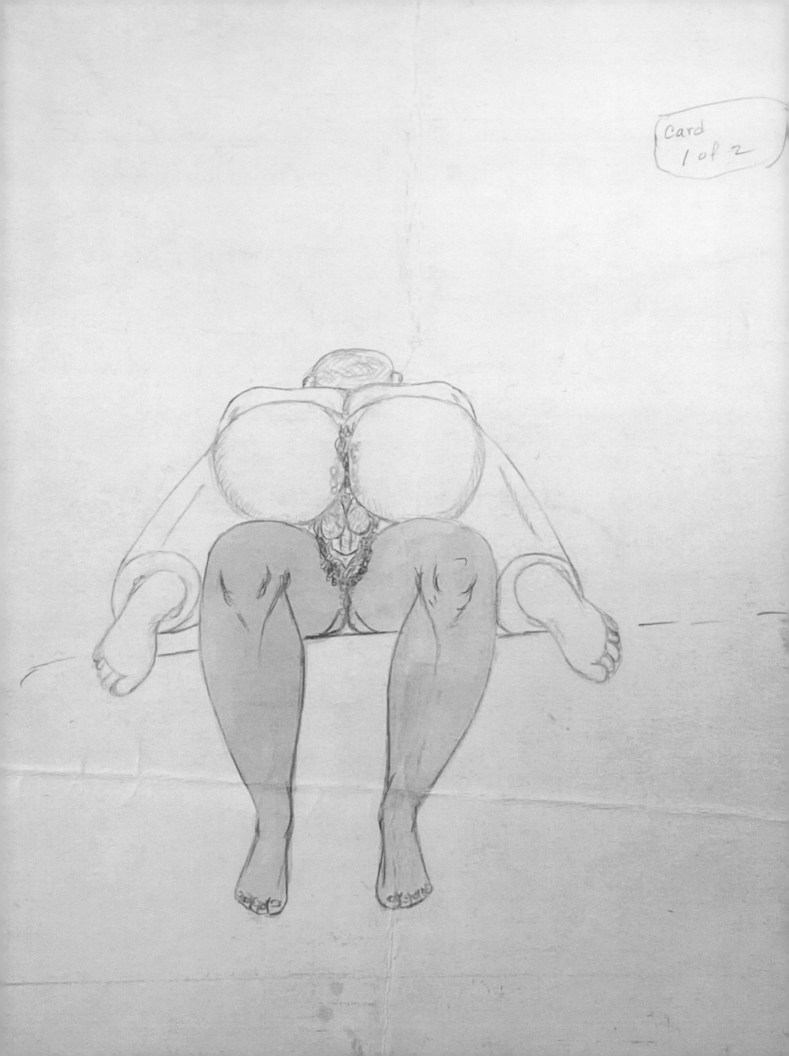

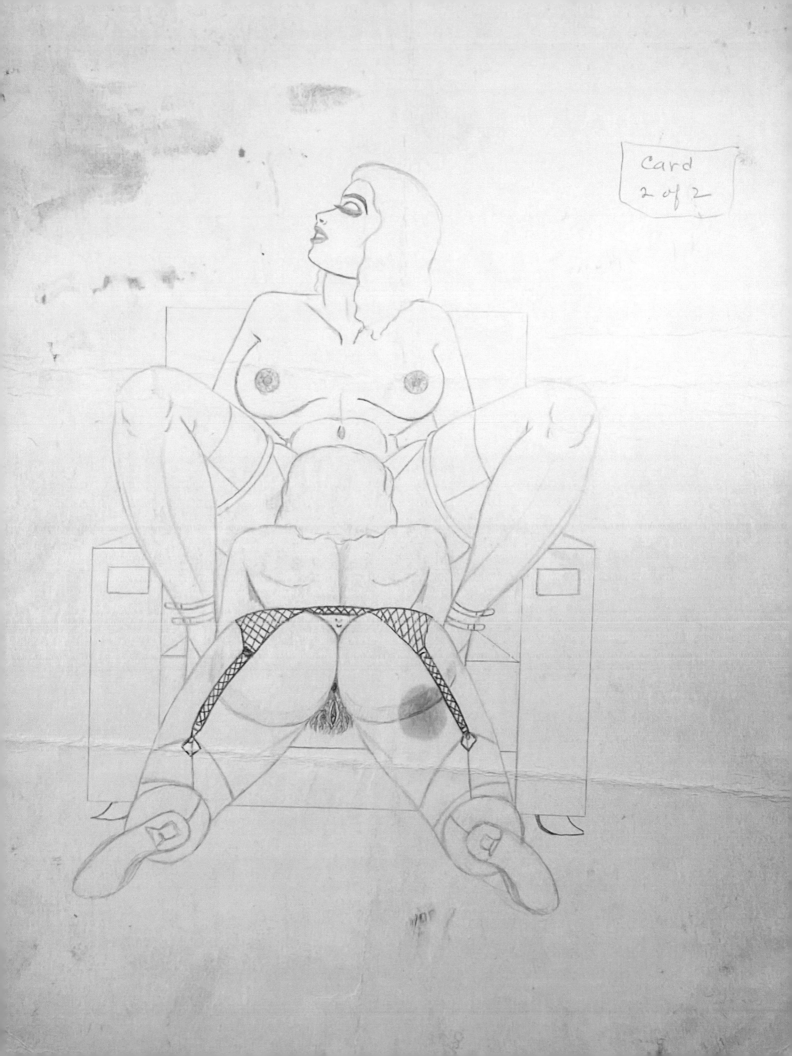

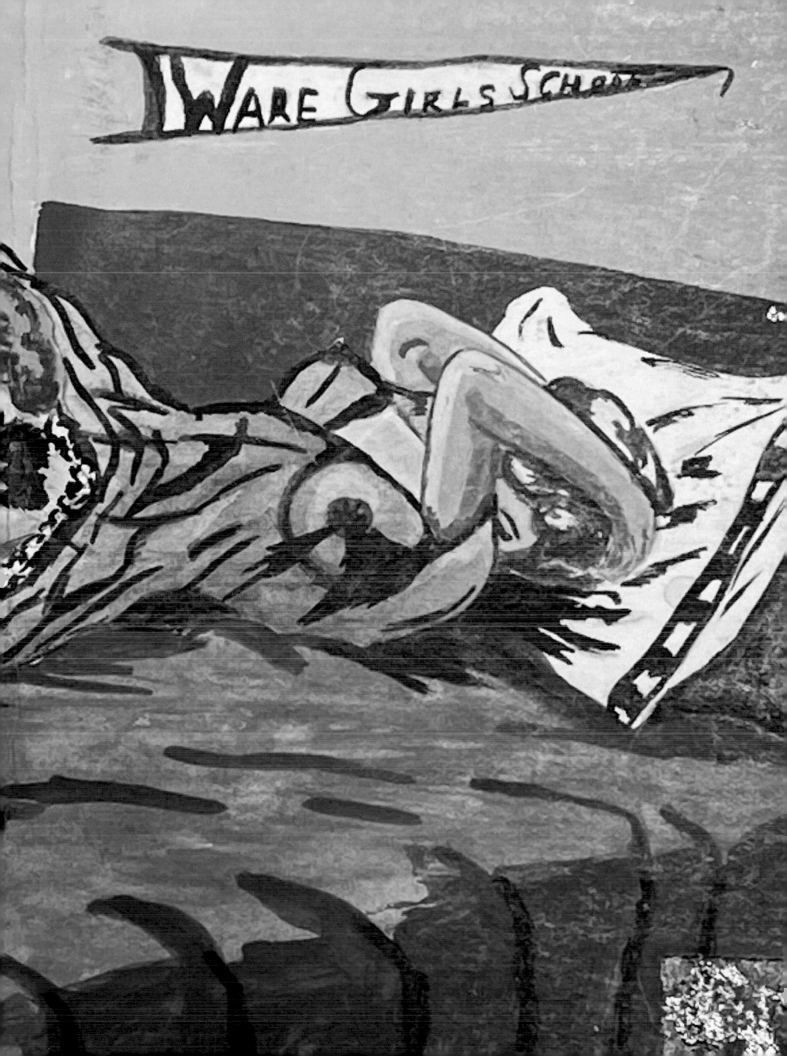

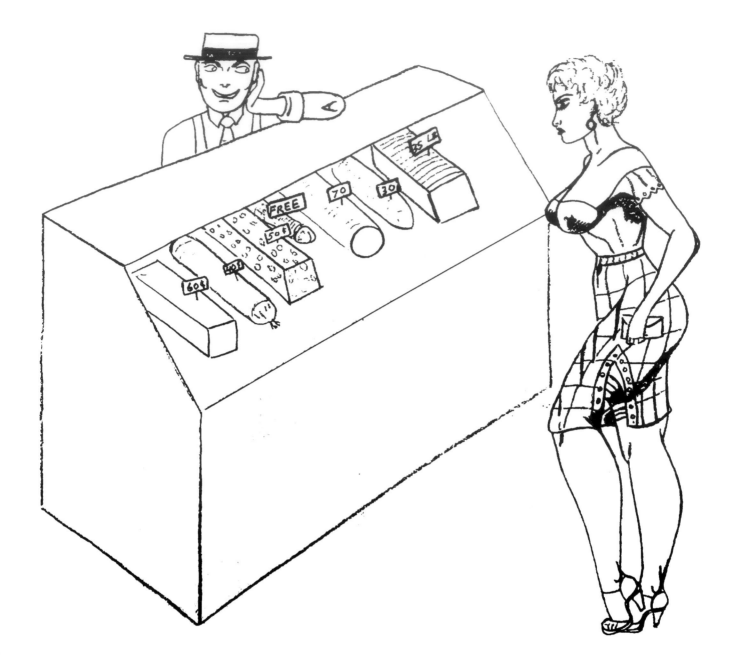

'SON AS OF RIGHT NOW YOU
ARE TOO BIG TO SLEEP WITH
YOUR MOTHER AND ME.

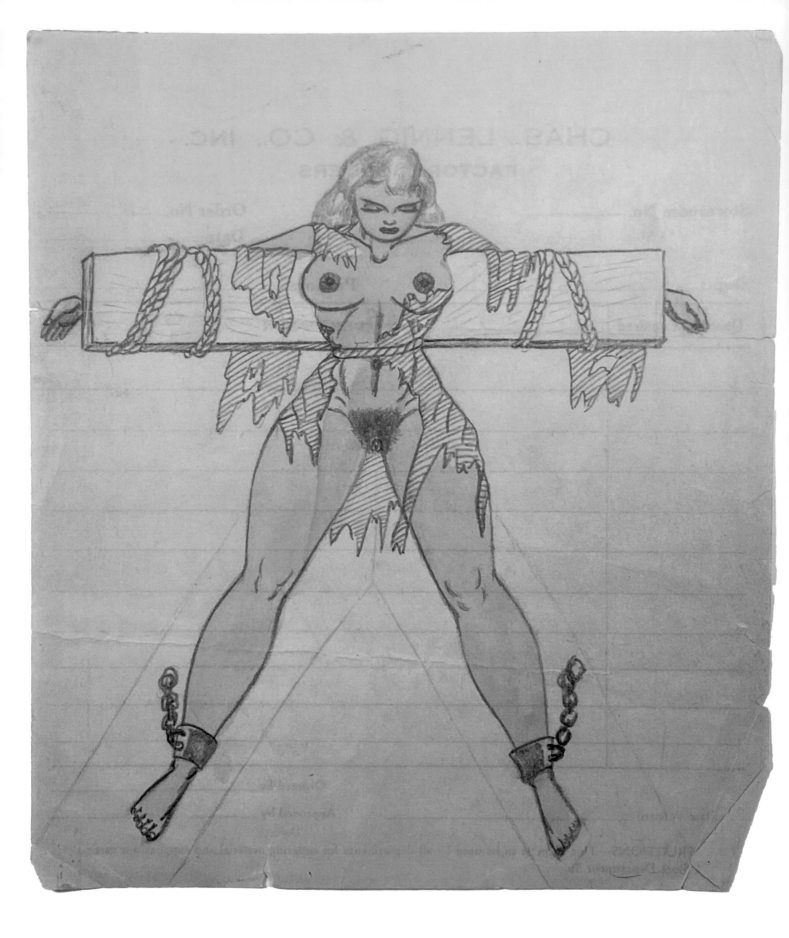

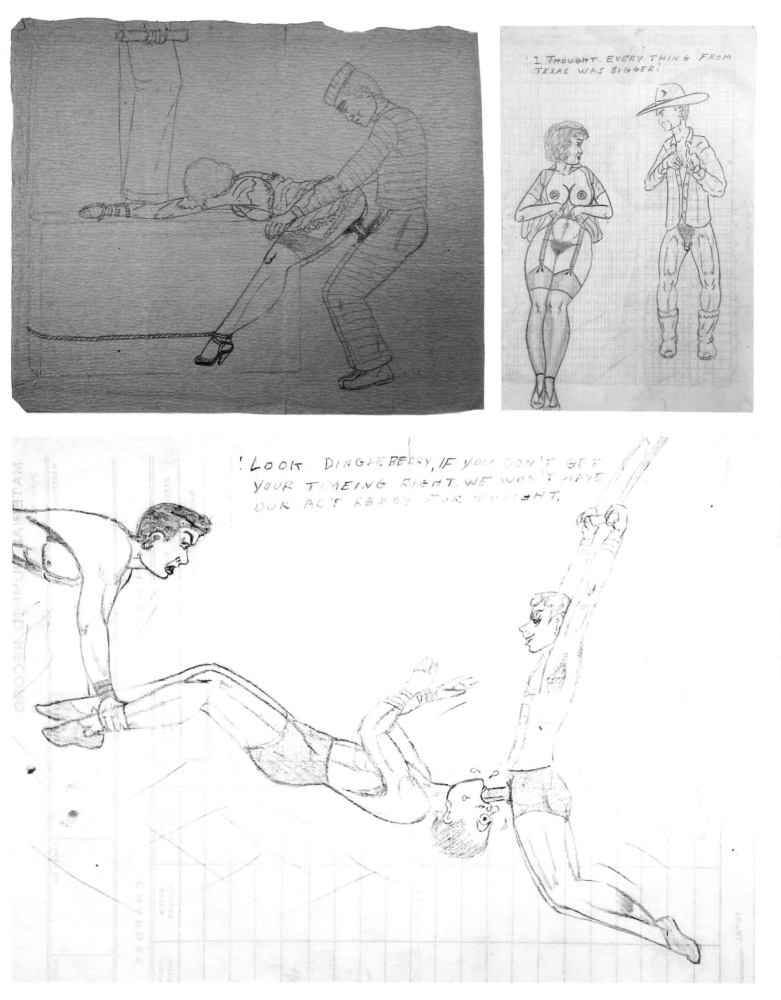

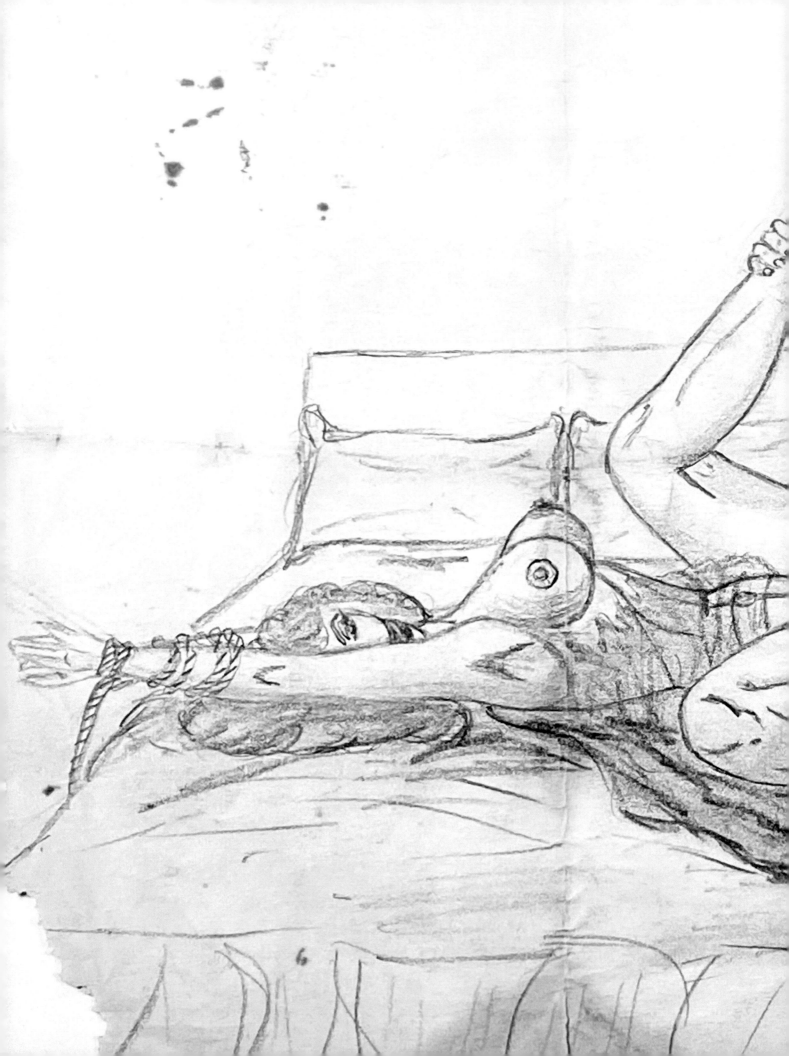

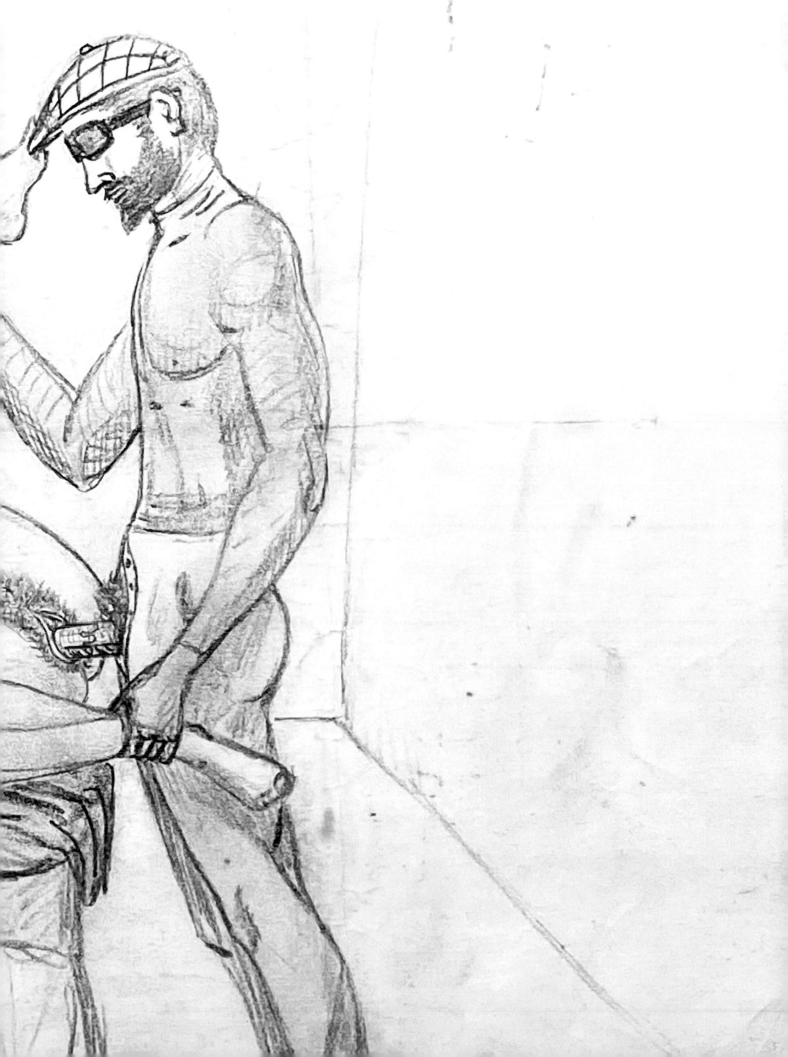

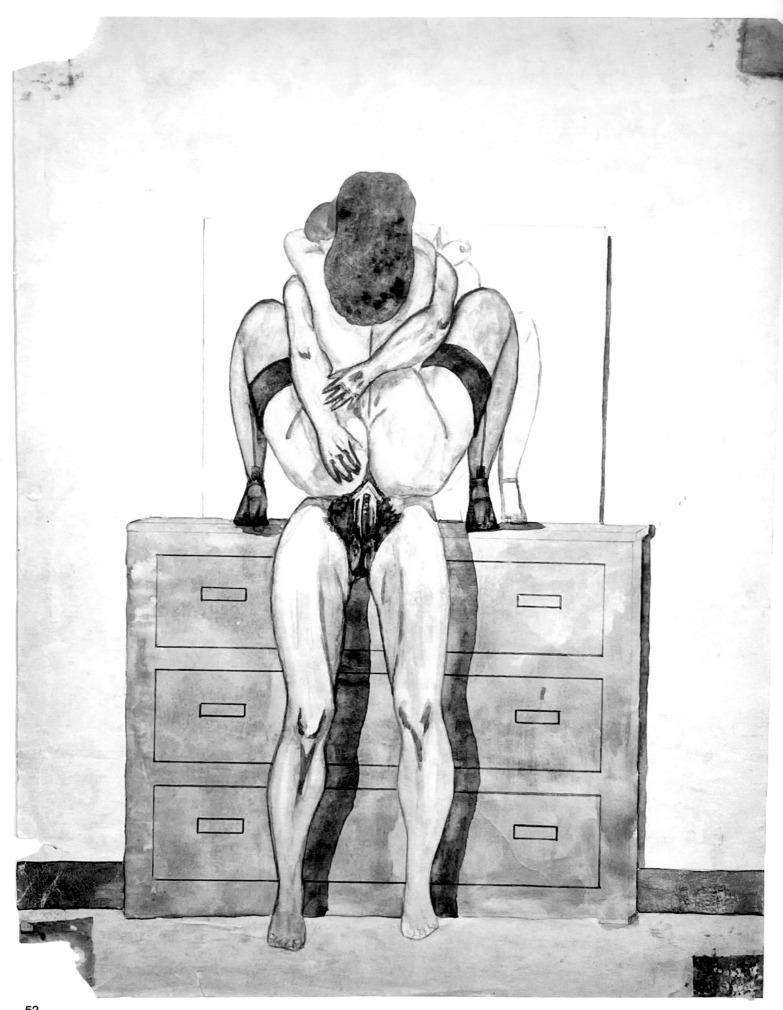

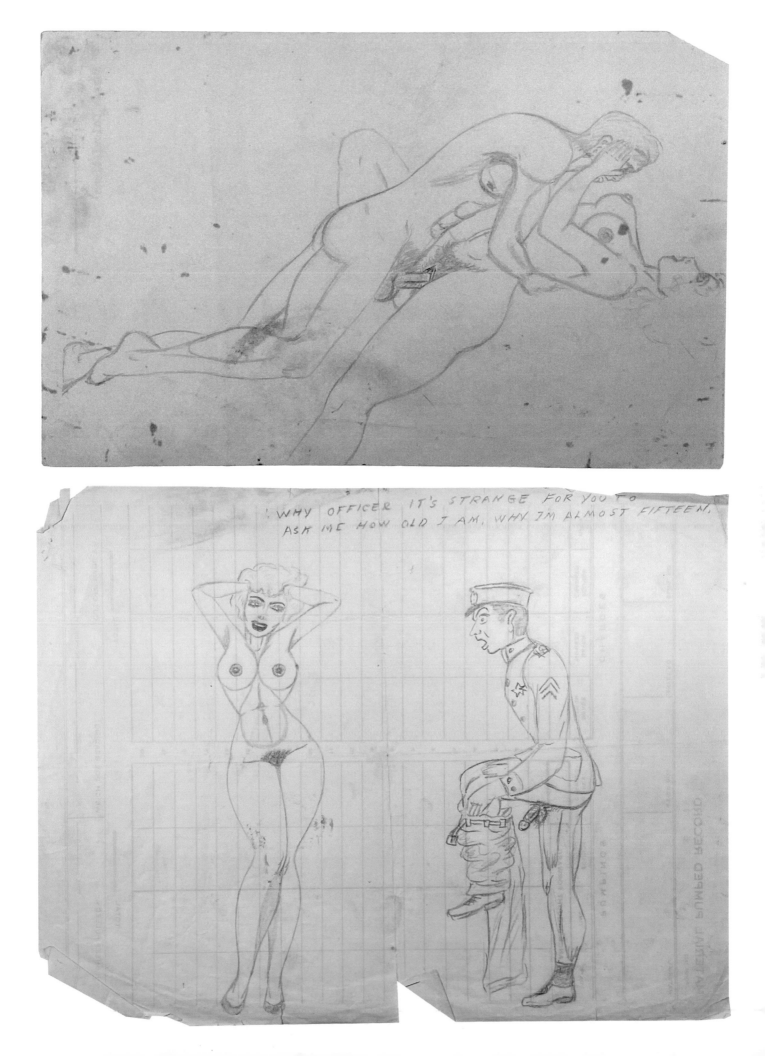

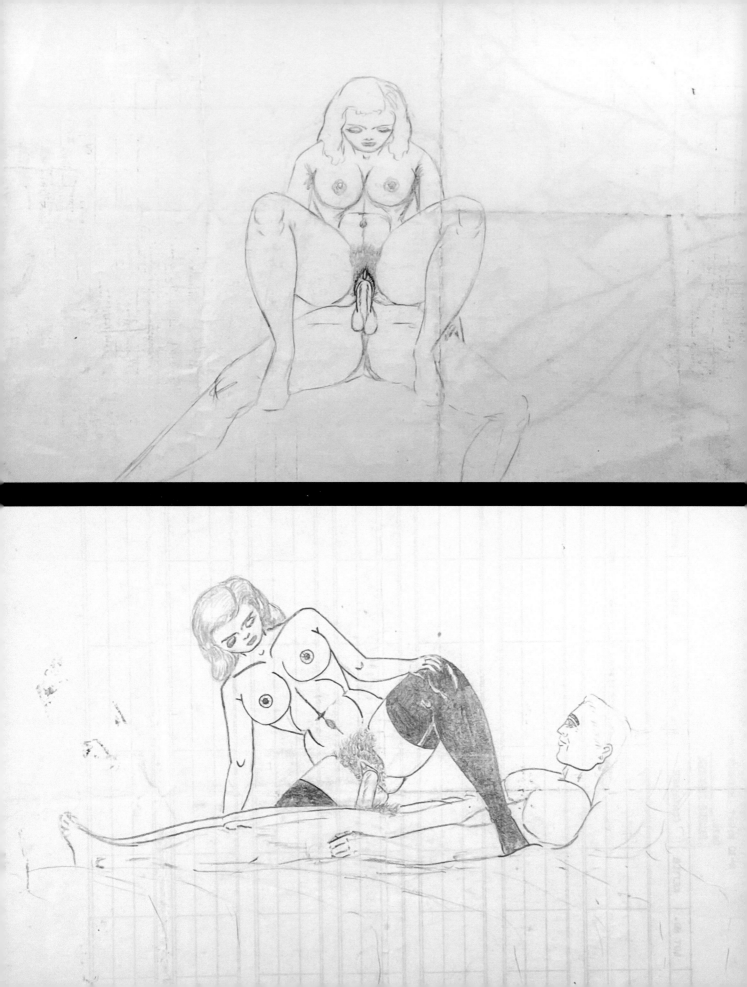

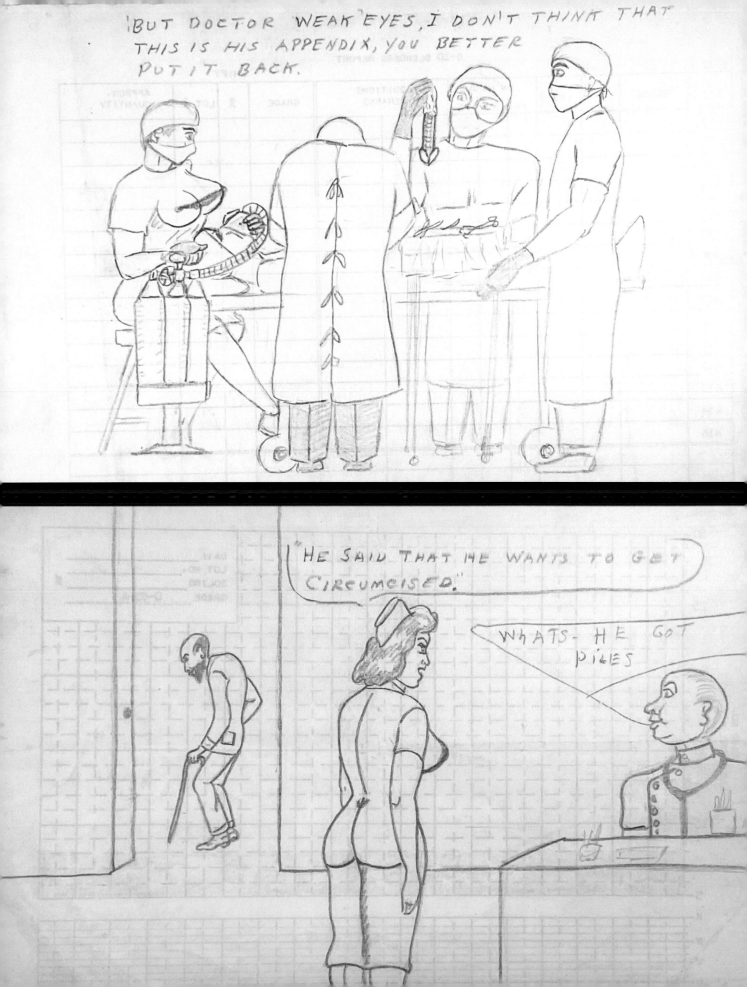

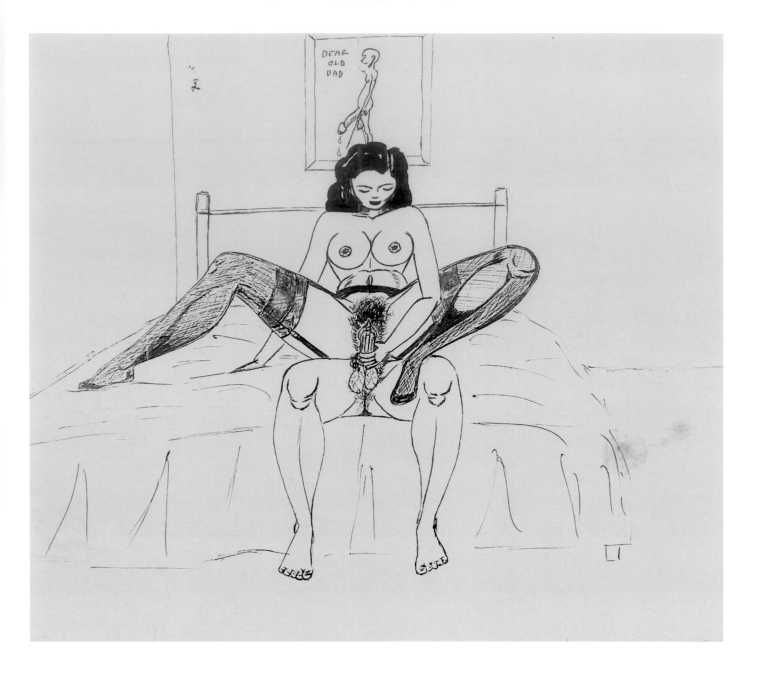

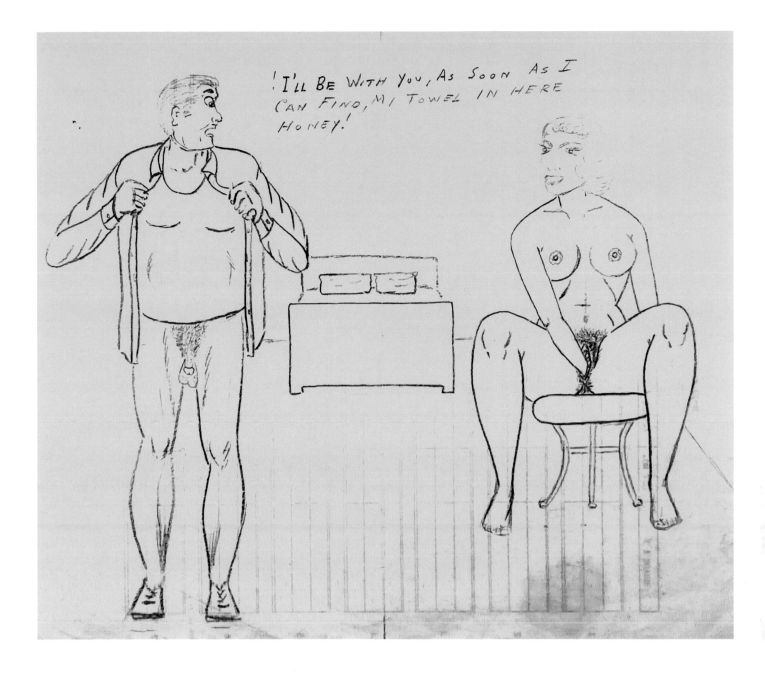

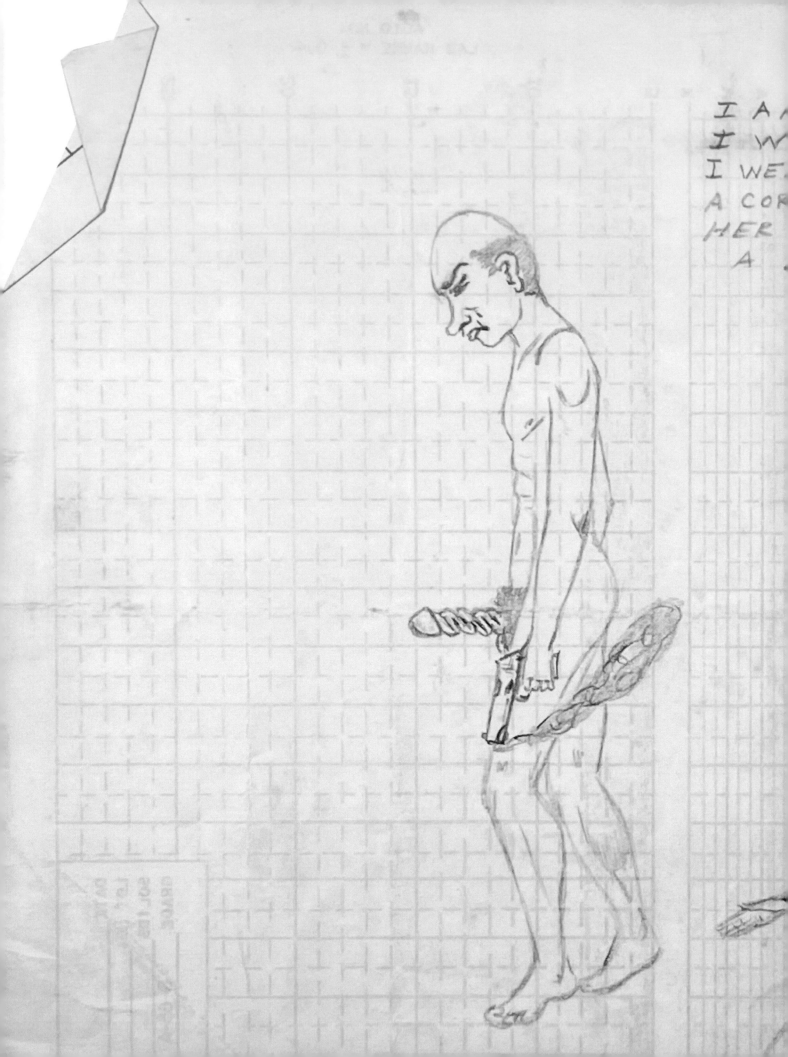

A GUY NAME DAFFERDICK,
BORN WITH A CORKSCREW PRICK,
ON A WORLD WIDE HUNT, FOR A GIRL WITH
REW, CUNT, WHEN I FOUND HER, I SHOT
AD, BECAUSE THE SONOFABITCH, HAD
T HAND THREAD,

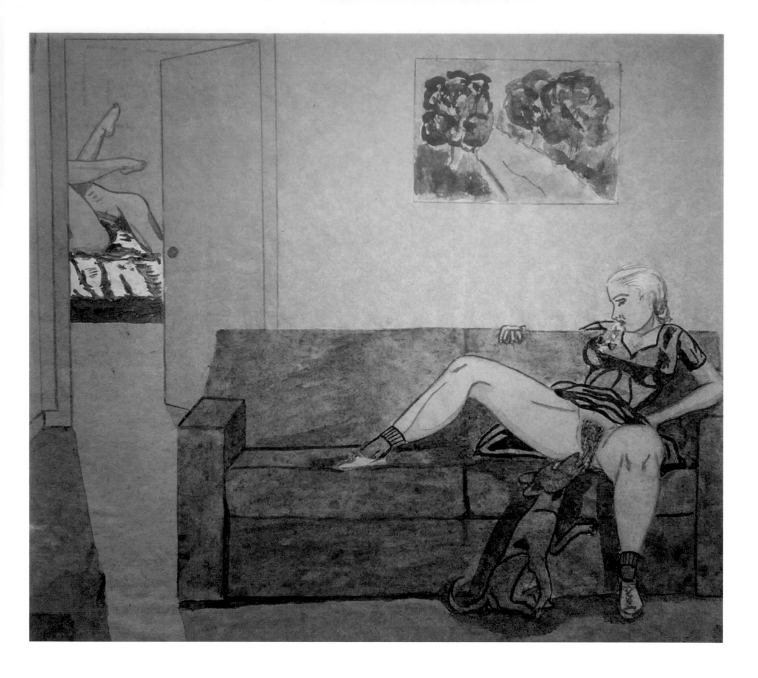